Susan Hiller

ries ...

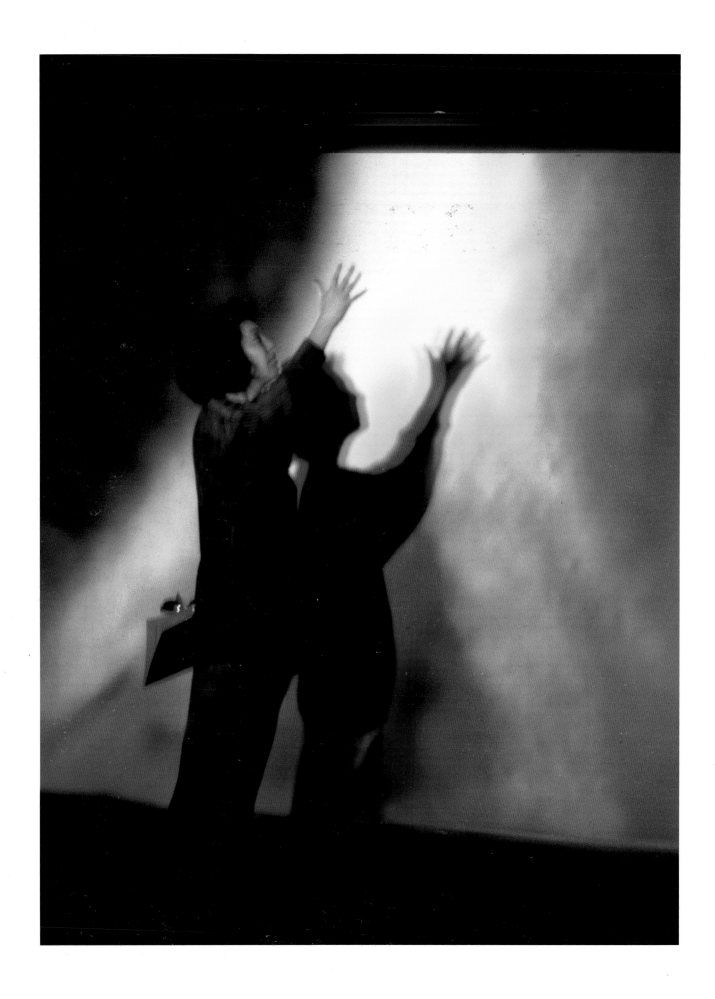

The artist in front of *Belshazzar's Feast* (1983–84), bonfire version, Kettle's Yard, Cambridge 1989

Susan Hiller

TATE GALLERY LIVERPOOL

Contents

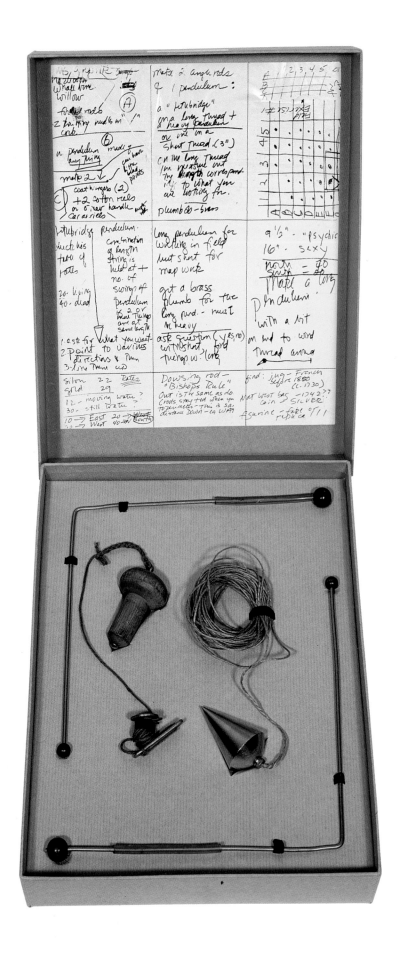

38. *At The Freud Museum* (1992–), detail, *VIRGULA DIVINA/water witching*

Preface

It is with great pleasure that we mount this exhibition. An American who has lived in London since 1973, Susan Hiller has been a hugely influential figure for a younger generation of British artists, both in her artistic practice and as a teacher. Hiller uses ephemeral, everyday objects, telling their stories and extracting new meanings from them, producing art which is both visually stimulating and emotionally compelling.

Although she has exhibited 'current' work in several galleries including the Museum of Modern Art in Oxford (1978), the Ikon Gallery in Birmingham (1981), the Orchard Gallery in Derry (1984), and Matt's Gallery (1980) and the ICA (1986) in London, Susan Hiller has never before shown a substantial number of works in all their variety. In the exhibition *Lifelines* in 1990, Tate Gallery Liverpool showed her wallpaper paintings. We are delighted now to present this major exhibition, spanning Hiller's career from 1973 to the present. While not a full retrospective, the exhibition offers an opportunity to experience at first hand the great range of Hiller's art and influence.

In the course of the planning of this exhibition, two important works have been acquired for the Tate's Collection: *Monument* and *An Entertainment*. *An Entertainment* was shown at the Tate Gallery in London in *Rites of Passage* in 1995. This present exhibition brings *Monument* together with *Belshazzar's Feast*, an earlier acquisition for the Collection, and places them in the context of works borrowed from other public and the artist's own collections.

The exhibition was selected by Judith Nesbitt, formerly an Exhibitions Curator at the gallery, and organised by the Exhibitions department in Liverpool. We are especially grateful to the Gimpel Fils Gallery and to the Faculty of Art and Design, University of Ulster, Belfast. The Arts Council and the John Creasey Museum, Salisbury have generously loaned works to the exhibition. We thank Guy Brett for the text he has contributed to this publication, and Rebecca Dimling Cochran for the work she has done with Susan Hiller to compile the catalogue information. We are indebted to *Frieze* magazine for permission to reprint their interview of Susan Hiller by Stuart Morgan, and to Catherine Kinley for the text she has written for the exhibition leaflet. Our thanks also go to Adrian Fogarty, Tony Campbell, David Connearn, and to Herman Lelie, the designer of this catalogue.

Above all, we thank Susan Hiller, for giving so extensively of her time and energy in preparing the exhibition.

Nicholas Serota Lewis Biggs
Director *Curator*
Tate Gallery *Tate Gallery Liverpool*

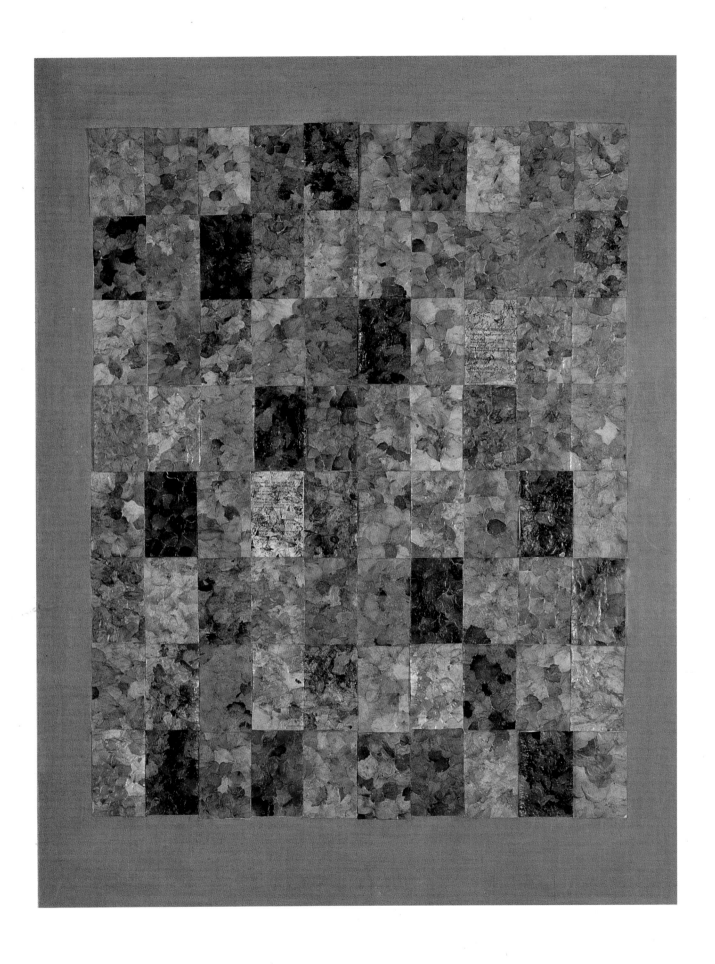

23. *Sentimental Representations in Memory of my Grandmothers (Part II for Rose Hiller)* (1980–81)

Introduction

Fiona Bradley

Susan Hiller works with a wide variety of materials, using them to find as well as generate meaning. She has made art from postcards, photobooth portraits, wallpapers and shadows, as well as photographs which she takes herself of often overlooked details of our everyday environment. She interrogates her materials, spinning stories around and from them, then finding appropriate media through which she may communicate these stories to a gallery audience. This has led her into a wide diversity of practice: she has made paintings, sculptures and photography; audio, video and book works. Hiller's work itself tends to become a source of new material as she continues to find meaning in objects she has produced as well as in that which inspired their production. She often reconfigures work as it is shown and re-shown, and she deliberately destroys some work each year, coaxing new meanings from the (often literal) ashes of the old.

Making an exhibition is a form of story telling, and one of which the artist is fully aware. This present exhibition is not a full retrospective. Instead, a very particular selection has been made, which focuses on works in public collections in this country, and contextualises them among less well-known works from the artist's studio. A narrative is being extracted from the work, with the aim of giving the viewer the time and the space to become familiar, or re-familiar, with the art of Susan Hiller. The exhibition represents the culmination of an additive process: it presents a pattern through an accumulation of carefully chosen details. The viewer is asked to participate in the making of the pattern, is required to collect together the meanings that will contribute to an understanding and enjoyment of the art as a whole. The exhibition functions as a matrix in which the artworks each have their allotted space.

Participation is a condition of Susan Hiller's art. It may be direct, as in *Monument*, which invites the viewer right inside it. It may be by implication, as in the video works which ensnare the viewer by unfolding their secrets over time. Each work engages the viewer, offering a system of structured looking whereby a first, distant or general impression is enriched into a wealth of detail as a closer approach is made. There is a constant shifting from whole to part and back to whole as the viewer advances towards and retreats from the works, negotiating a manipulated rhythm between watching and reading, looking at and looking into.

Hiller has said of her work that she is 'retrieving and reassembling a collection of fragments'. As an artist, she 'makes something potentially new out of remaindered items… what it means as a whole is up to the viewer to decide'. She acts as a mediator, selecting and presenting items for the consideration of the viewer. Sometimes she is deliberately neutral, as in *Enquiries/Inquiries*, in which quotations from English and American encyclopaedias are placed side by side in front of the viewer. At other times, the artist becomes a curator: in *Dedicated to the Unknown Artists* she analyses, classifies and documents hundreds of postcards of 'rough sea' from various seaside resorts.

Magic Lantern is an accumulation of both visual and aural detail. Circles of light appear and disappear before the viewer. Pure, coloured light – red, blue and yellow – they leave after-images as they fade, plunging the viewer into phenomenological uncertainty. At the same time, real and illusory noises wash around the room – the sound of the artist chanting in the sing-song rise and fall of improvised vocalisation, recordings made in empty rooms which may or may not be the 'voices of the dead'. Where the coloured circles overlap they mix to white light, a visual counterpart to the 'white noise' always threatened by the sounds on the tape. Laden with accumulated meanings, *Magic Lantern* twice articulates the additive process crucial to all Hiller's work. A viewer is free to take a long or a short view; to read meaningful details back into the pregnant whiteness, or simply to enjoy the fleeting, inexplicable beauty of its blank presence.

In contrast to the mechanically-driven *Magic Lantern* stand the two hand-made panels of *Sentimental Representations*. Again based on the repetition of detail, these panels are built up from single rose petals. The placing of the petals is an act of love: each of Hiller's grandmothers was called Rose, and the petals are metonymic substitutions for the women Hiller has loved and lost. In building an artwork out of rose petals, Hiller is repeatedly naming her grandmothers, summoning them in their remembered entirety from the fragmented detail of their names. Similarly, *Monument* assembles photographs of funeral monument plaques. Each one represents a person, resumes the life of that person: 'William Drake lost his life in averting a serious accident to a lady in Hyde Park, April 2 1869, whose horses were unmanageable through the breaking of the carriage pole'. The plaques function like gravestones, summing up the lives they commemorate. The viewer is invited to reassemble the reality of these lives from the reported details of their deaths. The plaques also represent the artist's life: Hiller photographed forty one of them, and was forty one at the time. The tape that accompanies the plaques insists 'each section of *Monument* represents one year in the artist's life'.

Monument and *Sentimental Representations* use words like objects, material fragments from which whole sentences – whole lives – may be conjured. Hiller makes words behave like the other, often overlooked, details she finds. She takes nothing for granted, but interrogates her words, asking them to tell her their stories. She devises strategies to help the viewer see words as full of potential, rather than received meaning. In her automatic writing works, Hiller juxtaposes handwriting

with typescript. The handwriting is produced automatically, the artist responding to the dictates of her own unconscious as manipulated by 'other' beings (the Sisters of Menon). The result is a form of writing which demands to be looked at before being read. The words produced are like found objects, the results of involuntary gestures. The typescript, on the other hand, reminds the viewer that these found objects are in fact part of a code, fragments of meaning we can put together to form a whole, albeit, in this case, a whole which remains fractured and incomplete.

At the Freud Museum is a combination of words and objects which are put together as a commentary on art, the artist, the viewer and the museum or gallery. Hiller was invited to make a work in Sigmund Freud's last house, which has been turned into a museum. She spent time there, assembling fragments – details – which spoke to her of Freud and of his, and her own, intellectual project. Freud, the father of modern psychoanalysis, formed the notion of a correspondence between the inner life of an individual and the external world of language and of objects. His work on dreams convinced him that the things we dream, and the words we use to talk about them, are clues to the workings of our unconscious mind and hence our identity. In the Freudian system, words and objects have a symbolic resonance.

Hiller's artwork plays with the symbolic, and associative, functioning of words and objects. In a museum showcase, she presents a series of forty-four boxes, which contain 'rubbish, discards, fragments and reproductions which seemed to carry an aura of memory and to hint at meaning something'. The boxes are all twice named, the second name translating the first (Heimlich/homely), offering a synonym (Panacea/cure) or a phonetic transliteration (Cowgirl/kou'gurl). The work was first shown in the Freud Museum, which Hiller has described as 'the site of a provocatively poetic accumulation of contexts'. Within the museum, she offered other accumulations, other contexts. In Tate Gallery Liverpool, her work becomes a kind of museum in miniature, one dedicated to the artist as well as to the psychoanalyst. It presents a repository of Hiller's dreams, ideas and ideals.

At the Freud Museum collects many of the themes at work in Hiller's art. Rather than simply resuming them, however, it extends and alters them. A museum showcase, from a distance it seems to have a mission to explain. Up close, this mission is diverted by the proliferation of new and fascinating detail, through which Hiller leaves viewers to navigate their own course. In her artist's book *After the Freud Museum*, Hiller speaks of the 'sequences, patterns, repetitions and gaps' which structure the book and, perhaps, all her work: 'A major factor in all the work I've ever made, it seems to me, is the designation of spaces where viewers and readers can experience their own roles as active participants – collaborators, interpreters, or detectives'. Susan Hiller invites the viewer to spend time with her works, to try to figure out how to fit their seductive fragments into the, perhaps illusory, completeness offered by the whole. She shows us that all objects and all words have personal, associative and symbolic stories to tell. She suggests that things are often worth a second look.

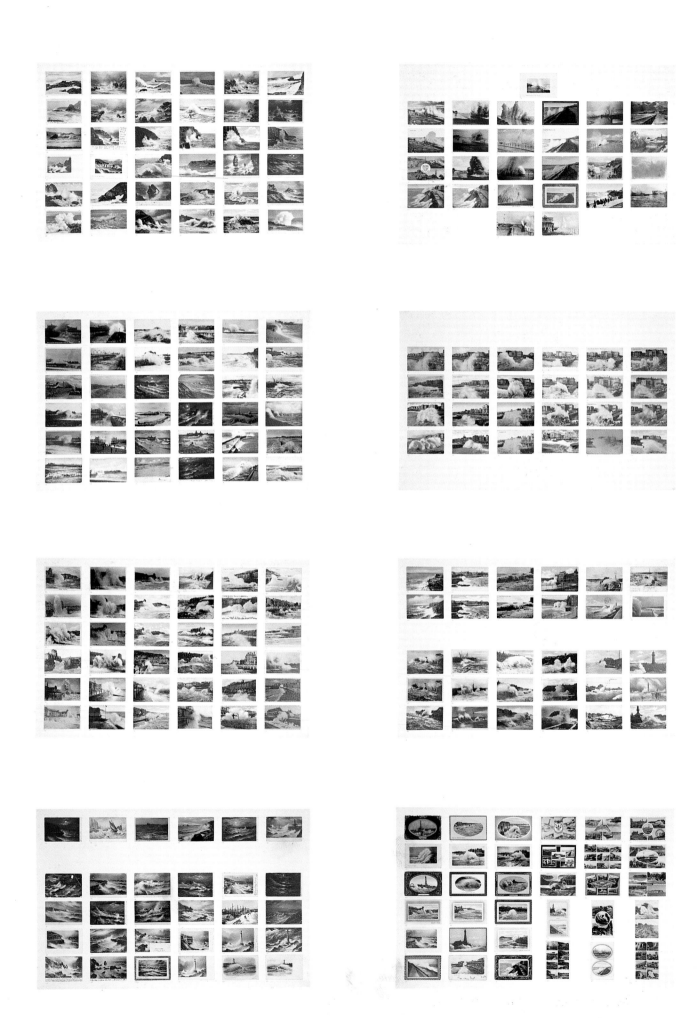

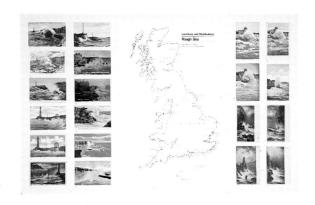

3. *Dedicated to the Unknown Artists* (1972–76)

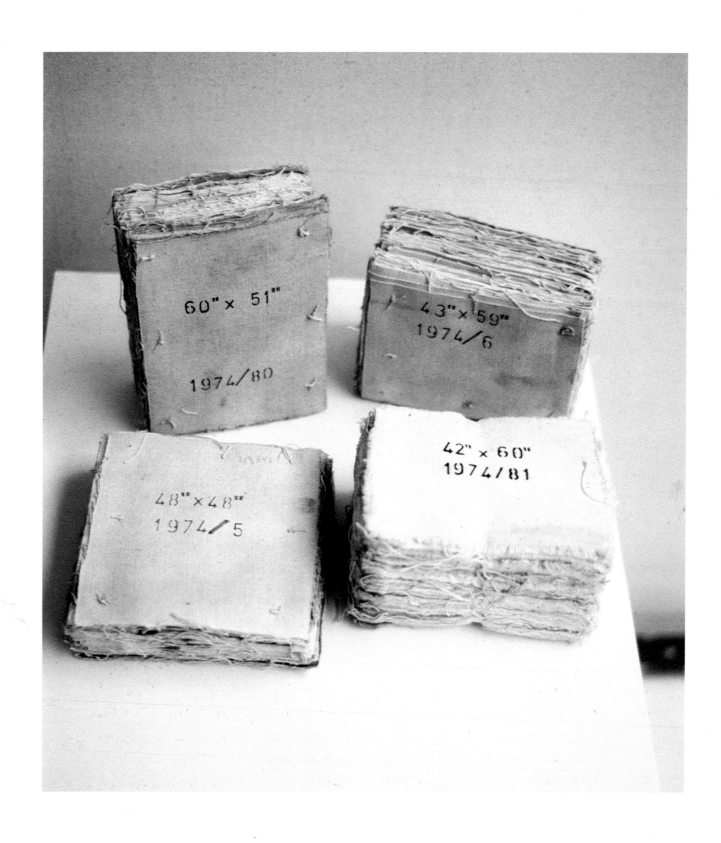

7, 8, 10, 11. *Painting Blocks* (1973–81)

The Materials of the Artist

Guy Brett

It seems almost perverse to begin an essay on Susan Hiller with a discussion about painting, especially since there are no paintings in this exhibition! Hiller has become known for the extreme diversity of her work: not only a diversity in the materials and media out of which it is made, but a diversity in the use of space, the mode of presentation, the address to the spectator, every aspect of the *mise-en-scène*. Each work has found means adequate (or poetic) to its purposes. Hiller is no 'installation artist'. She has practised painting at various moments of her career, and therefore, in the material and the conceptual sense, painting as a medium weighted with tradition becomes an intriguing point at which to begin.

It becomes obvious at once that Susan Hiller's practice of painting has been anything but pure. This is not a judgement against its aesthetic beauty; on the contrary, its aesthetic beauty is intimately connected with the way in which Hiller has interfered with the integrity of painting as a myth, a sort of heroic myth. The heroic myth of painting is always revived to justify a hierarchy of aesthetic practices, with painting at the top, which is usually accompanied by a conservative attitude to artistic, and even social change. With acute paradoxical insight, Hiller has questioned this idealisation of painting precisely in order to reveal more of its nature as a transformational process.

Hiller's 'interferences' have been supremely material. Their conceptual implications have never been a merely cerebral matter that can be separated from the sensuous. For example, in the early 1970s, and again in 1980, she cut up some of her previous abstract paintings into squares. On the earlier occasion these were stitched together in random order in a patchwork to form new canvases. The later ones were re-exhibited as bundles called *Painting Blocks* on small individual shelves. These were part of an event Hiller staged at the nascent Matt's Gallery in London in 1980, called *Work in Progress*. Adapting the gallery with minimal means as her own 'workroom', she spent a week in public gradually unpicking the threads of the canvas of previous paintings, and then re-suspending them as skeins and knotted masses about the walls, in the form of 'thread drawings' and 'doodles'. Beginning in 1972, Hiller has burned a number of older paintings on an annual basis and exhibited the ashes for example in small round stoppered bottles, tagging them with the name of the painting and calling them *Hand Grenades*. A notion of material transformation ran through all these works:

By emphasising the provisional and unfinished nature of things, these projects demonstrate the real continuity between objects (things) and events (processes). By moving my own works into another state of being, I allow them to participate in life, instead of curating the work as though it were entombed in a museum. There is also a hidden psycho-political agenda: these works express my interest, at a very deep level, in the tactile quality of vision, 'touching with the eyes'.[1]

In a different tactic towards painting, Hiller has worked intensively along its borderline with other visual forms. To begin with, she does not assume the ideal white space of the canvas or paper but has worked upon existing imagery: photobooth portraits, enlarged postcards, wall-papers. Nothing new in this in principle: it was already established in Cubist collage. But in a sub-tle way Hiller has given the practice a new set of dynamics. Existing imagery is not used merely as a passive ground or as fragments of material to be marshalled by the artist's will to form. Instead, the medium of the found or given, with all its social connotations, and the medium of the wilful or spontaneous, with its connotations of freedom, are in a state of equal dialogue, mutual analysis and contradiction. The new dynamics are confirmed by the presence of that ubiquitous 'calligra-phy' of Hiller's, which seems to veil and unveil simultaneously both the mechanical printing and the painterly marks, and into which both sets of signs are transformable. This is particularly true of certain wallpaper paintings in the *Home Truths* series where the masking with paint of the insis-tent patterns – *Masters of the Universe, Secret Wars, Freefall, Heartfelt* – **creates** the free-flowing cal-ligraphy as a transparent screen.

Two masterly works of equivalence and mutual suggestibility are *Sentimental Representations in Memory of My Grandmothers*, wall-hung pieces of 1980–81. In place of paint we have rose petals suspended in an acrylic medium. The natural graduations between red, pink and ochre of the rose petals produce a rarefied pointillism which is further modulated by being arranged in rectan-gles or 'pages'. These are interrupted occasionally by small sheets of photocopied rose petals overtyped with words. A process of punning arises between the verbal and the sensory. The rose petals stand for paint, adding a tactile dimension to the visual and verbal (cf 'touching with the eyes' – Hiller, 'the rose of seeing' – Rilke), as well as the suggestion of a lingering scent in evok-ing the memory of the artist's two grandmothers, who were both named 'Rose'. 'Representations', in the title, takes on its double meaning of a 'depiction of' and an 'address to', embodied in the time-consuming process of fabricating the 152 pages of rose petals. In contrast to Hiller's photobooth works, for example, which depend for their poetry on playing with the debased and automated remnants of the great traditions of portraiture, *Sentimental Representations* ironically stress craft and show that the portrait of another is tied up in a mysterious way with the unique process of producing it. 'How is my desire related to my production?', the artist asks in one of the pictorial notes. As much as a painting, the work may be seen as a kind of secret ritual for connecting the private nature of her emotion with the public nature of her audience. Could it be that Hiller was referring to art traditions as well as to her grandmothers when she described the thoughts and feelings accompanying the making of this work as 'opening a closed book'?[2]

It will probably be obvious that my discussion of painting has been a way of drawing attention to the material nature of Hiller's work. One can expand from painting to consider the remarkable variety of *mises-en-scène* which Susan Hiller has used to effect the encounter between materials and spectator. Each particular work can be seen as a kind of model of communication, a model which moves from source material, or primary data, through the artist to the spectator in a whole range of new ways. Every work, in its spatio-temporal form, as well as its content, can be seen as proposing an enlarged and collaborative notion of the self.

Each of Hiller's works involve a process where an already-existing artefact, or artefacts, have been brought in from outside and reconstituted in the artificial, contemplative environment of the gallery. Immediately a relationship is set up between the original location of the material and the artistic location, even if that 'move' has precisely the effect of questioning whether an original location can ever be found. People, the public, are present in both places but our conventional perceptions are changed by the change of location.

Similarly the gallery *mise-en-scène* is often an echo of an ambience in real life – for example the artist's workroom in *Work in Progress*, a park bench in *Monument*, an archaeological site in *Fragments*, a fireside in *Belshazzar's Feast*, a child's room in *Night Lights*, etc – though never striving for literal truth. Indeed, I believe the character of Hiller's *mise-en-scène* was formed early on by a brilliant exploitation of a certain convergence perceived between Minimalism and the techniques of scientific enquiry (to both of which she had an ironic relationship of mingled respect and critique). The liberating aspect of Minimalism was its attention to the physical nature of present space, real time and the body, to the exclusion of composition, emotion and symbolism. A particular and witty example is Robert Morris's *Location* (1963), a grey wall plaque with tiny changeable number-wheels giving its exact distance from ceiling, floor and adjacent walls. A more general example is the perennial use of a non-compositional grid structure, which is one of the clearest links between Minimalism and the classificatory, tabulatory and mapping procedures of science. Just as Hiller was impressed by Minimalism/science's removal of obfuscation, its economy and precision, she remained profoundly conscious of all that it denied.

Thus we have an early work like *Dream Mapping* (1974). Typically, paradoxes abound. The notion of precise location is applied to the apparently free-floating activity of dreaming (after a practice period of a month, seven people spent three nights in sleeping bags within 'fairy-circles' of mushrooms in a field in Hampshire, and then drew maps of their dreams). In the work the artist presented these maps singly and superimposed on one another. Again, the activity of mapping, usually applied to the physical world, was here transferred to something immaterial, and, in further ironic play with science, the work followed a process of collaborative, group authorship to produce 'an intensification of subjective experience'[3], rather than conclusions reached by a single overseeing interpreter who conducts the experiment. The work itself has no fixed form and it is

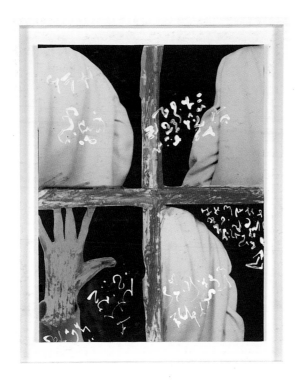

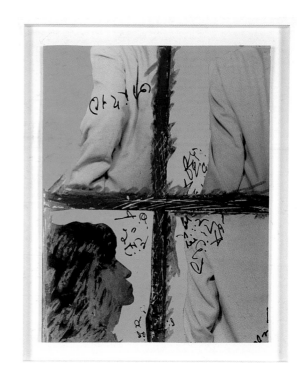

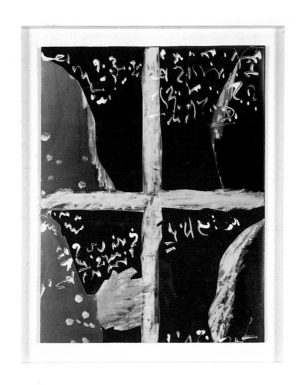

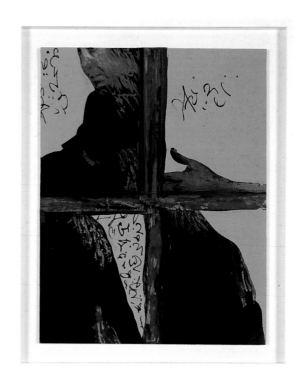

25. *Lucid Dreams I* (1983)

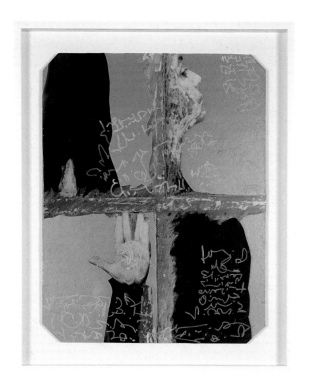

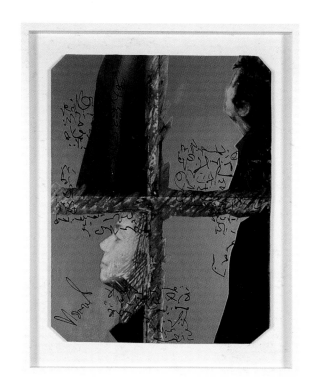

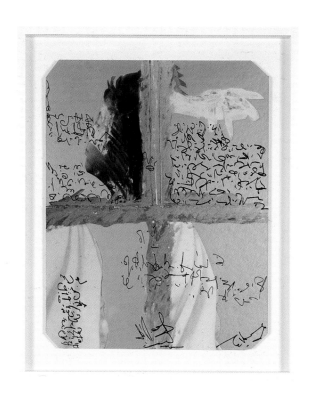

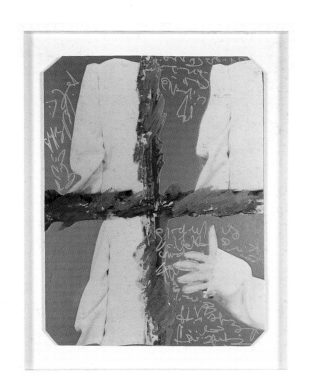

26. *Lucid Dreams II* (1983)

always a pleasure to see how Hiller will install it; I especially remember the maps transcribed to cover entire walls and part of the ceiling at the ICA in 1986, accompanied by a book of the dream maps in an illuminated cubby-hole.

In Hiller's work, the shift from the 'real world' to the 'gallery/museum' is not absolute, but has the quality of a two-way exchange. The park bench, and the fireside, are places for passing time and reverie in the everyday world, whereas the archaeological site is a part of the earth that instantly becomes a museum. Exhibition spaces themselves can be involved in these shifting iden-tities. Hiller's *Work in Progress*, for example, was deliberately made for Matt's Gallery during its early days. It had been the artist Robin Klassnik's studio and he defined its aims, in an inaugural press-release, in contrast to institutional establishments, as a 'brief but concentrated stopover for new work'. Taking on the potential the gallery offered of being seen as a workplace, Hiller used it for a process of 'undoing', precisely in order to challenge 'the evident fallacies in the patriarchal notion of a 'fully achieved' work of art.'[4]

My first and lasting impression of Hiller's now-classic *Fragments* (which I saw at the Museum of Modern Art in Oxford in 1978) was of a kind of dismantling of 'achieved' and monumental space. 100 small broken pieces of Pueblo pottery were placed on 100 sheets of sketchbook paper laid on the floor in a grid formation. Each sheet also contained a gouache painting of a pottery fragment, different from the actual one resting on the paper. On the walls were further fragments in transparent bags, a photograph and various forms of written statement. It was not simply that the work was composed of fragments – both material and verbal – but that they remained frag-ments, refusing to conjure up defined wholes, either artistic or scientific. Yet the disposition of the material in the space had a powerful physical – I could call it **sculptural** – presence. The ordering effect of the grid, the bags, the pages, the tabulations, played against the inconclusive-ness of the small pieces and their patterns – an inconclusiveness which, however, suggested some larger imaginative reality of which these were indications or tokens. Not knowing becomes a form of knowing, as Hiller has so often said. The larger reality existed half in dream, half in wak-ing life, as the many written-down statements of the Pueblo women potters attest.

In *Fragments* Hiller delicately unravels archaeological and anthropological methods to move beyond the primitivist mind-set which sees other cultures as a source of exotic commodities. At the same time she proposes the model of a practice which shows women as 'primary makers of meaning'.[5] *Fragments* was a pioneering work in both senses. Its dispersed space hints at the possibility of a kind of non-exploitative continuum between cultures where common dilemmas can be examined.

Sisters of Menon (1972–79) posed the problem of a collaborative self in a completely different way. Or apparently different since our terms of reference are continually being confounded. In place of collaboration as a relation between oneself and others, we have collaboration as facets of the

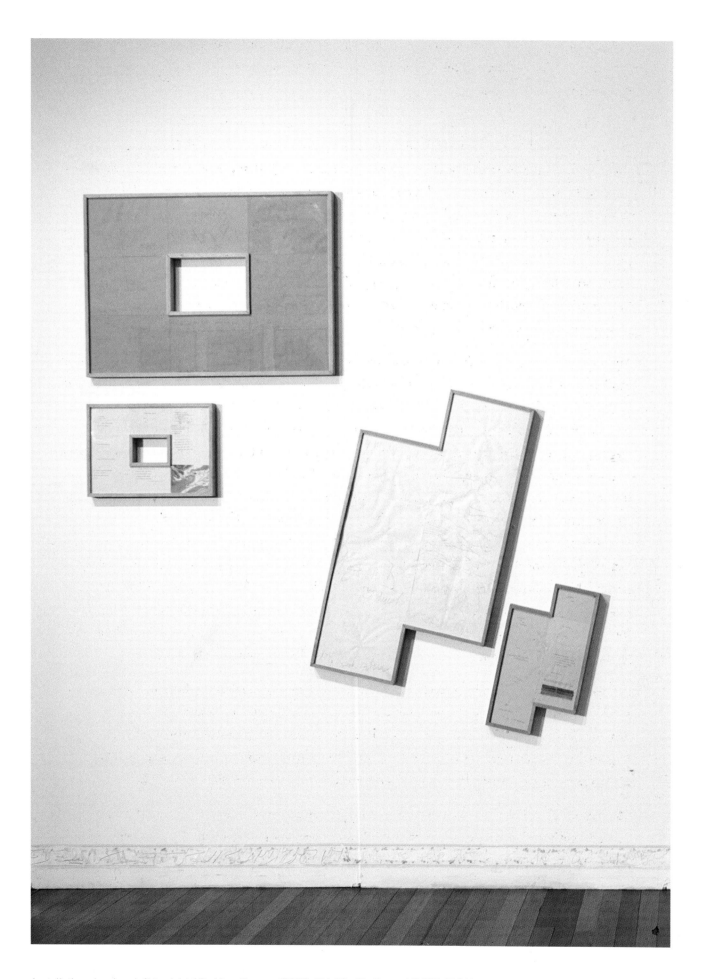

Installation showing, left to right 18. *Mary Essene*, (1975-81) 19. *My Dearest* (1975-1981)

individual, or single, self. An enigma. *Sisters of Menon* is a wonderfully enigmatic work. It can be seen as a network, a cluster, where all the themes we are considering – location, origin, agency, authorship, authenticity, collectivity, gender and time – are brought together in a questioning model of the self. *Sisters of Menon* and other works in the series, are wall hung pieces, composite arrangements of papers bounded by frames of eccentric shape. Each one is an annotated record of an episode of 'automatic writing' which the artist conducted in the early 1970s.

In automatic writing the subject supposedly relinquishes the entire learned process of self-control involved in writing on a sheet of paper, and yet continues to write. I suppose only the former, non-automatic, conscious self can judge the interest of the results, but in Hiller's case they were extremely interesting. In *Sisters of Menon*, straying wildly over the rectangular paper in blue pencil, she received the insistent, chant-like 'representations' of a trio of female voices. The archaic tone, the collective voice, the possible influence of place (the experiment was conducted at the village of Loupien, near Sète, in France), all stimulate the mystery of where the words 'come from'. But Hiller turns this preoccupation with 'origins' around to consider the nature of present reality, and the multiple composition of the self. What is the 'me'? Where are one's edges and limits?:

> 'My' hands made the marks that form the inscriptions, but not in my characteristic handwriting or voice. My 'self' is a locus for thoughts, feelings, sensations, but not an impermeable, corporeal boundary. I AM NOT A CONTAINER.[6]

In her automatic writing pieces, Hiller assumed the role of medium in challenging conventional models of an artist 'communicating' with an audience. The condition of 'receptivity' rather than 'expressivity' was made primary. These themes were considerably expanded in *Belshazzar's Feast/The Writing on Your Wall* (1983–4). One way of seeing this haunting and complex work is as a dense, interwoven fabric of meditation. The piece is shot through with humour and irony, since the notion of meditation is stretched all the way from modern 'media' to ancient 'prophecy'. In between is the timeless experience of meditation (reverie, dreaming, hallucination).

Consider the layers. First the *mise-en-scène* of gazing into the fire, which has changed with each showing. The work is structured around the theme of a 'warning' about the ills of society, given the dignity of cultural tradition in the story of Belshazzar's Feast and a modern aura of banality and debased traditions in the newspaper reports of people's hallucinatory images seen on their switched-off TV sets late at night. As usual with Hiller, the conventional hierarchy of value and dignity between these two social instances is delicately questioned. The biblical story of Daniel's prophecy, which itself centred around the interpretation of nonsensical marks, is conveyed via a child's (Hiller's son Gabriel's) selective and candid recollection of Rembrandt's baroque painting of the event. Archaic-sounding humming, alternating with the newspaper extracts on the sound track, seems to evoke the timelessness of meditation and its links with breathing. This slow

rhythm, where sense yields to sensation, is carried right through to the flames on the video which are gradually abstracted as if they were random pulsations of the charged electrons which make up the TV image. What *Belshazzar's Feast* perhaps attempts to make manifest is that borderline between language/sense and pure cosmic energies, fluctuating in the ethical core of each human being.

Belshazzar's Feast can also be seen as a sort of experimental situation where the 'hand' meets the 'machine' in relation to the enigma of marks, their interpretation, and material energies. There is the voice of Gabriel describing the hand of God which came out of a blaze of light and pointed at the marks on the wall, and on the other side there are the electronic shapes derived from flames on the monitor and the reports of people's hallucinations on their TV screens. Juxtaposition and overlay of manual and mechanical is a persistent theme in Hiller's work. It is one of the ways a new model of the psyche is proposed through enquiries which transform painterly traditions. We have touched on the duet or duel between painterly processes and mechanised printing in Hiller's photobooth portraits and wallpaper paintings. *Belshazzar's Feast* brings into this equation another theme which had been gathering strength from early on: that of light.

Interestingly, light in Hiller's work had a kind of double birth at which notions of painting were paradoxically present. In early 1973 she held an exhibition at Gallery House in London which occupied two rooms. In the bigger room was shown *Transformer*, 'a large tissue-paper and nylon filament structure', covered in marks suggesting symbols or non-existent alphabets, and suspended freely in space, so that the semi-transparent sections 'rustled with every breeze, and as they stirred, the surface markings (in gold, silver and red/brown inks) glittered'.[7] In the small cubicle next door, in provocative contrast, was *Enquiries*, consisting simply of a projector throwing mechanically on the wall, without starting or finishing point, slides of the printed pages of a popular encyclopaedia. This work, whose conceptual rigour I remember at the time finding difficult to like, Hiller herself described as 'a painterly piece'. By this she meant that it originated in a sensuous response, not an abstract idea or an *a priori* concept: 'materials were of primary importance… not only the cultural materials, the linguistic data or factual statements, but their concrete manifestations as texts, paper and ink.'[8]

Later on I was able to see the equivalences behind the apparent dichotomy. The delectable *Transformer* did not rule out the presence of 'facts' (the material energies animating the work, hinted at in the title), nor did the mechanical and factual *Enquiries* rule out sensibility and ambiguity. Indeed, the encyclopaedia pages themselves fail to exhibit any systematisation of knowledge or 'grand design', but are small clusters of facts, unconnected, which reach out into reality only so far: fragments, really, which put one in mind of the vastness of the whole. Light, then, begins to emerge in two senses: as a form of cosmic energy and plentitude lying behind all painting,

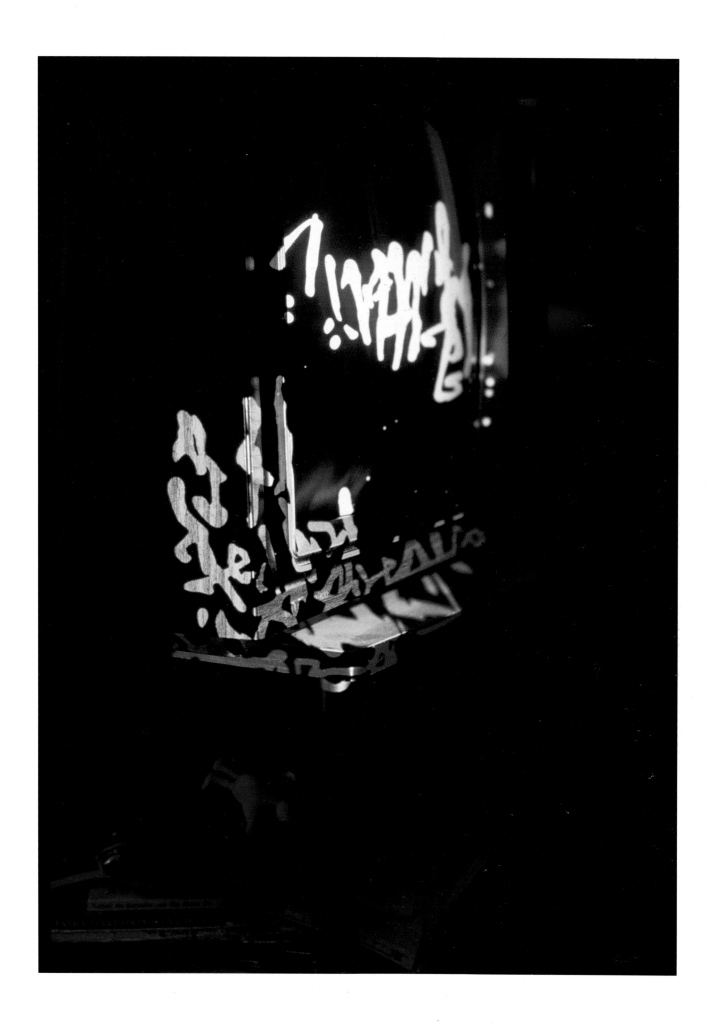

29. *The Secrets of Sunset Beach* (1987), details

drawing and visual representation, and as a beam, a metaphor for thought, which 'throws light' on reality and is surrounded by darkness.

In the history of art we can perhaps discern an active and a passive treatment of light. On the one hand there are sources which actively manifest energy and emit light, often with mystical or magical overtones: haloes, auras, emanations, nimbusses and rays. On the other hand light appears in a passive role as the means of revealing the material world. Of course this distinction is deeply unstable and paradoxical in that 'otherwordly' light is a thoroughly material phenomenon, and the light of 'representation' as much dissolves the solidity of the world as fixes it. This ambivalence has persisted into the 20th century. In fact it could be said to underlie modernist innovations in a striking way which has been suprisingly little studied. Integral to the destruction of traditional representation in the development of abstract art, for example, was a 'materialist' analysis of the pictorial order: the surface, frame, edge, plane, colour, line, brushwork. There was implied, or openly stated, the view that inherited codes of representation covered over elemental energies contained, for example, in horizontal/vertical oppositions (Mondrian) or the interaction of colours (Albers).

The destruction of form released these energies. The optical interactions of painted surfaces evolved into the actual reflection, or the direct projection of light (as in Vantongerloo's prisms and, later, Takis's *Signals*). Somehow the two traditions of light remained present and it was hard to know if the new energies released were 'material' or 'spiritual', the result of a quasi-scientific investigation of the real or of an imaginative vision (artists themselves were often ambivalent on this point: Vantongerloo, for example, could say at one moment that his paintings and constructions were entirely the result of mathematical calculations, and at another that art such as his could give insights into the 'structure of the universe' which could be communicated by 'no other than aesthetic means'[9]).

In Susan Hiller's *Elan* (1982) the active principle of light is crossed with the gestural energy of calligraphy (by exploiting an accidental discovery in the photographic process, the automatic writing appears as if done with a light pen on a black void). *Secrets of Sunset Beach* (1988) is a marvellously intricate conflation of active and passive light. Projected light, TV light, sunlight, reflections and shadows interweave with one another and with the cultural bric-a-brac inside a fantasy beach hut. These themes are resonantly presented, summed up almost, in *Magic Lantern*.

Magic Lantern (1987) is an optical experience of measured beauty and simplicity. Three projectors triggered by electronic pulses throw large-scale on the wall a sequence of circles of brilliantly coloured light. Sometimes the circles overlap, producing new colours, and sometimes they fade to total darkness that washes in with a surge, like the sea covering an island of sand. In a curious way, it is hard to tell if the after-images of colour produced in the darkness are not pre-images of

the next burst of light. Along with this optical uncertainty between the objective fact of the projected colours and the subjective, spectral ghost images, runs a parallel aural experience. We follow on the sound track the persistent attempts made by the psychologist K Raudive in the 1960s to prove 'scientifically' that the tape recordings he made by leaving his machines running in silent and empty rooms revealed, when amplified, the voices of the dead. The pedagogical, rather graceless voice of the narrator contrasts in turn with the meandering rhythm of the artist's chanting, similar to that used in *Belshazzar's Feast*.

Light/dark, silence/noise, pure colour/empty space, objective facts/subjective fantasies, material energies/cultural signs, the mechanical/the human, science/art: *Magic Lantern*'s deceptively simple components arouse a fascinating web of reflections about the dilemmas accompanying cultural developments. Many threads could be followed, each one a sequence of paradoxes. Raudive, for example, was driven to find in the blur of mechanical/electronic noise the voices of the dead, but the dead he conjured up were selective: mostly famous male historical figures, and a female 'helper'. His 'culture' limited his 'science'. Why was he not content with the silent rooms? These, in Hiller's work, may be taken as a reference to the material/spiritual nature of abstract art, analogous to the colour circles and the wordless singing, which reach towards a wider concept of both identity and language, more global, more communal.

Magic Lantern is also of course a hommage to the slide projector, being titled with the name of its Victorian ancestor. Scientific discoveries in the 19th century were quickly exploited as a means of popular entertainment, a duality Hiller obviously enjoys.[10] As well as its relation with the history of painting, *Magic Lantern* can also be connected with theatrical traditions. Not with theatre in the grand manner, but a marginal history which can be traced from the sideshows of medieval fairs and mummers' performances, through dioramas, lantern slides and the early cinema, to the forms of modern media. These connections bring us round again from pictorial references to the broader experience of Hiller's *mise-en-scène*. At a time when the fashion for 'installations' has led to rather routine expectations, it is inspiring to watch Hiller's employment of a material like light. From the large projected slides of *Magic Lantern* or, later, from video projections covering the four walls of an enclosed room in *An Entertainment* (1990), she can move to curious objects which exploit the concentrated, jewel-like quality of 'unprotected' 35mm slides (*Light Sticks*, 1991–2). She can move from room-sized installations to the inside of a cardboard specimen box (*At the Freud Museum*, 1994, and later boxes). Occasionally different registers meet, as in a recent exhibition where the warm pools of light from the candle-like bulbs of her *Light Sticks*, reminiscent of night-lights in a bedroom, contrasted with the cool, museum light of a vitrine where the Freud boxes were lying open.

An Entertainment can be seen at one level as a material meditation on the changing nature of the 'scene'. A one-person, hand-made drama (Punch and Judy performances, the primary data of *An*

Entertainment), emanating from a tiny proscenium, even worn as a sort of suit by the puppeteer, in front of an outdoor audience of children, is reconstituted as a high-tech light-show covering the entire inside walls of a room-sized cube which surrounds the audience. From the bodily and muscular to the filmic and electronic, the cloudy projections dissolve all the perspectival co-ordinates on which the proscenium is based.

In a way the cube is like the inside of a head, a dreaming head, but it is not, as with virtual reality apparatus, a private head. It is populated by others, strangers we become aware of in a disordered, unstructured way very different from the linear seating of the conventional theatre or cinema. The subject-object positions become fluid, continuously changing into one another, because the 'others' become part of the experience for every individual and there is no place from which the work can be completely known. These experiences become all the more thought-provoking when one realises that the interlaced themes of this video installation concern various forms of denial: denial of the other, or of the other in ourselves which we relate to by trying to annihilate it; denial of what we 'know' in the realms of life, art and science, a denial either absent-minded or deliberate of those deep truths, light or dark, which are masked in 'entertainments'.

In one of those cross-connections which art always gives one the liberty to pursue, the crudely-rendered skull which flits across the walls in *An Entertainment* may be compared with the ten skulls which appear as vertical rows of 35mm slides in the three *Human Relations* light sticks (1991–2). All the revitalising associations of popular culture, the carnival, Halloween, the Day of the Dead, in the Punch and Judy character of 'Death' and 'the Ghost', may be compared with the dusty stasis of the material remains photographed in *Human Relations*, scientific relics of the development of evolutionary theory. Yet a human intensity and fragility unites both, and visually both are dialectical structures of light and darkness, where the voids of the eyes and nose cavities are as significant as the solid material. Both are masks, finally.

Susan Hiller, speaking of her glass ash-filled *Hand Grenades*, says that she regards them 'as just as interesting to look at and experience as paintings', and that maybe this reflects 'a wish for everything to be seen as having the same potential for insight'.[11] It would be hard to find a better definition of the starting point, and the achievement, of her art. It describes the way her art fits together with life, as a practice, as a process, interacting with it and shedding light on it.

1. Hiller, unpublished notes
2. Hiller, quoted in *Beauty and Other Works*, exh. cat., Arts Council of Great Britain (works purchased for the Arts Council Collection by David Brown), 1980
3. Hiller, 'Dream Mapping', *New Wilderness Letter 10*, New York, Winter 1981
4. Matts Gallery Press Notice, August 1st 1979
5. Hiller, interview with Paul Buck, *Centerfold*, Toronto, November 1979
6. Hiller, Sisters of Menon, Coracle Press, London, 1983
7. Hiller, *Inquiries*, exhibition broad sheet Serpentine Gallery, London, 1976
8. Hiller, ibid.
9. Cited in Margit Staber, *Georges Vantongerloo: Bilder 1837–1949*, Galerie Lopes, Zurich, 1977
10. See Johnathan Crary, *Techniques of the Observer: On Vision and Modernity in the Nineteenth Century*, Cambridge Massachusetts, 1990
11. Hiller, 'Beyond Control', interview with Stuart Morgan, in this publication

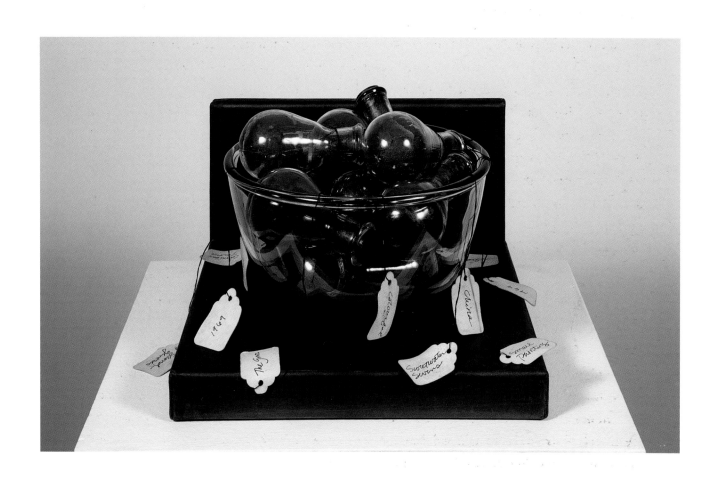

1. *Hand Grenades* (1969–72)

21. *Monument* (1980–81)

Beyond Control
An interview with Susan Hiller

Stuart Morgan

Stuart Morgan: You are attracted to things beyond your control.

Susan Hiller: I'm interested in things that are outside or beneath recognition, whether that means cultural invisibility or has to do with the notion of what a person is. I see this as an archae-ological investigation, uncovering something to make a different kind of sense of it. That involves setting up a situation which welcomes this perhaps anarchic, non-volitional stage of awareness.

SM: An unedited stage?

SH: Yes, in response to a situation structured to create a heightened or more precise awareness.

SM: Gender has been another concern.

SH: These things go together. Understanding the implications for perception and behaviour of my entry into language as a sexed subject, and understanding how this is definitely not the same thing as being limited to activities that are conventionally defined as feminine, in fact gave me the impetus to explore areas that used to be considered off limits in art.

SM: *Work in Progress* (1979) could be seen exactly as a so-called feminine art work: pulling your paintings apart thread by thread, turning them into something different.

SH: The idea of simultaneously making and unmaking could be traced to any mystical tradition. To associate it solely with women would be astonishing.

SM: Is it a means of prevention?

SH: That seems contradictory. In remaking my old paintings I wanted change, but everything changes inevitably. I just brought things more quickly to the point they would reach anyway. In contrast, the culture of art in our society involves fixing: putting things in museums and not let-ting them deteriorate. But in other societies, the kind of sculpture that influenced the early Modernists – African, Polynesian – is left to rot, raising the question of how continuity of style can exist to be emulated. We're different; we think that if we can't keep a painting perfect, we'll have no more painting in future.

SM: You, in contrast, continue your conceptual exercise of burning your work.

SH: Every year I transform some works into other formats. The series of burnt relics began in 1972. I placed the ashes of burned paintings in chemical containers that measure and contain what can't be contained. They are like burial urns too, and since I regard them as interesting to look at and experience as paintings, maybe it reflects a wish for everything to be seen as having the same potential for insight. Like traces or remnants, they point forwards and backwards at the same time.

SM: You also cut old paintings into equal sized rectangles and sewed those together, one on top of the other.

SH: I called them *Painting Blocks* (series begun 1970/71). Each has the scaled-down dimensions of the original painting. The project turns surface into mass, painting becomes sculpture. It's a material-based comparison. (At present in this country we have an untrue history of Conceptualism which suggests it is totally language-based.)

SM: Other early works, like *Dream Mapping* (1974) involved other people.

SH: That's right. In that piece participants collaborated to develop a system for the graphic notation of dream events. After about a month we decided not to work with words but with diagrams.

SM: Diagrams of what?

SH: Of dreams.

SM: Of what they saw in dreams?

SH: Or of the location of events, or of structures. People evolved their own notational system. For the last three nights we went to a site in the countryside where there was a remarkable occurrence of mushroom circles: fairy rings. In folklore, if you fall asleep in a fairy ring, you'll be carried away to fairyland, like in a state of altered consciousness. So on the last three nights everybody picked a fairy ring and went out and slept in it all night. Next day we collectively mapped our dreams, by which I mean that we first diagrammed or drew our individual dreams, then we superimposed them one on the other and came up with a collective dream map. I was writing a book on dreams with David Coxhead, so I was aware of all sorts of traditions about dream incubation, which means going to a special place to have a heightened dream – a pattern the world over for curing ailments – but also the idea of the collective evolution of a notational system for dreams. In many native American or Australian Aborigine groups such a system as an artform was not seen as representational: it's not a picture of a dream image but a set of notes in visual diagrammatic form. The two ideas came together in this place.

16. *Dream Mapping* (1974), detail

But then for me there was a difficulty, which was that work which began as a deeply-felt attempt to be non-hierarchical, non-elitist, non-product-orientated, outside-the-gallery-system, getting back to basics, working with friends, remained more elusive and more esoteric than a painting could ever be, because it was an enactment, a performance where no gap exists between audience and participants. They're the same. So on one level what had seemed a perfect solution was not really such a good format, because the experience of the piece could not extend beyond the original participants. What I retained from this series of pieces was the conviction that the other person has to be in the work or it isn't interesting to do.

SM: Is there a rift between your two kinds of practice in this early period?

SH: After several years of work that was on one hand Minimalist and materials-based, like the sewn canvases, and on the other hand immaterial and time-based, like the investigation pieces for groups of people, I really wanted to resolve the dichotomy. First I made a mental equation between materials and ideas. (That's why I've always said I have a materials-based practice). I made *Dedicated to the Unknown Artists* (1972–76), a 'rough sea' postcard work, and a slide piece called *Enquiries/Inquiries* (1973 & 1975) based on a sort of cultural catechism taken from popular encyclopaedias in Britain and the United States. (Hence the two spellings of the same word). These works used an approach which has remained important for me and comes out of Minimalism: putting together many similar units with tiny differences.

My work was starting to come together from about 1973. The early ideas carried through to later works that require the involvement of viewers in a different way. It goes back to Michael Fried's idea of the theatrical. He meant that invidiously. I took it differently. Because I come from a conjunction of Minimalism and Fluxus, I combined the interactive with the non-theatrical and turned this into another position which insists on the participation of the viewer as essential to the work. In *Monument* (1980–81), for instance, where the entire piece is activated by a person who sits on a bench listening to a sound tape, a person must be prepared to be seen in public performing a private act of listening. Since that person is seen by other viewers against a backdrop of photographic images, the piece exists as a tableau with a living centre, while the person is also part of the audience for the work. That was the kind of solution I arrived at for the problem raised by my earlier very private investigative works, which left behind only traces or pieces of evidence and documents. The thing that unifies everything is the use of cultural artefacts from our society as starting points. At the time, this was a new thing to be doing. If you think the idea through, you realise that every type of format is already an artefact, including stretchers and canvas, the television screen, so how could artists *not* be working with artefacts? In that sense, everybody is working anthropologically.

SM: And politically too?

SH: Well, it's work in the world, which contributes as much to knowledge and shifts in attitude as any other form of work. At the same time, art has a mirroring function; it can only disclose an image of what is already available to us. Because we are products of our society and culture, artists don't know anything that anybody else doesn't know, but we can show people, ourselves included, what we don't know that we know.

SM: You also made participatory works for hundreds of people

SH: Yes, *Street Ceremonies* (1973) in the open air in Notting Hill, involved about 200 people. Another much smaller group work made later the same year was called *The Dream Seminar*. Some people from both of those pieces took part in *Dream Mapping*.

SM: Artists' early works prepare for what is to come. In your case, it was a total assault on the integrity of the art object and a full-scale attack on the idea of the individual.

SH: I didn't see it as an attack; more, that I was wounded and had to make a response. I'm not saying I consciously felt a sense of damage. Those were confident days. It was wonderful to be in England. People were crossing borders freely. It was part of a mood: a different, more integrated period. We were lucky to be around. My confidence came from having emerged at that period. I had nothing to lose, so why not follow my own predilections? I liked being where I was. There was no pressure to establish an art career. Everyone had abandoned all that; you did whatever you did, and if it turned out to be music or painting or writing, great. Or you didn't have to do anything, you could just grow vegetables. We had shrugged off the need to define ourselves, have a career, get a mortgage, all those things.

SM: One work that emerged from this attitude was *Sisters of Menon*.

SH: Those scripts emerged on a visit to France, where I was staying in a small village. It was there that the *Sisters of Menon* events occurred. Admittedly, the stage was set for some altered states of consciousness, but it wasn't anything peculiar; I accepted this as part of the way images and ideas were transmitted, at least among artists, because you find that in art and also in science, unconnected people in different places seem to come up with the same idea at the same time. So it didn't seem freaky. Suddenly, I started to write and write and write. That was in 1972, and then I lost the manuscripts or misplaced them or put them away somewhere and forgot about them. When I came across them again a few years later, I decided that if I formalised the material it could become a work. At that point I added four pages of commentary. The cross-shaped formation is simple to arrange: X number of A4 pages. That made sense since a cross appears in the text itself; the four pages of commentary became four ends, four panels at the ends of the arms of the cross. The formal configuration and commentary pages were done in 1979, the year I found the lost scripts.

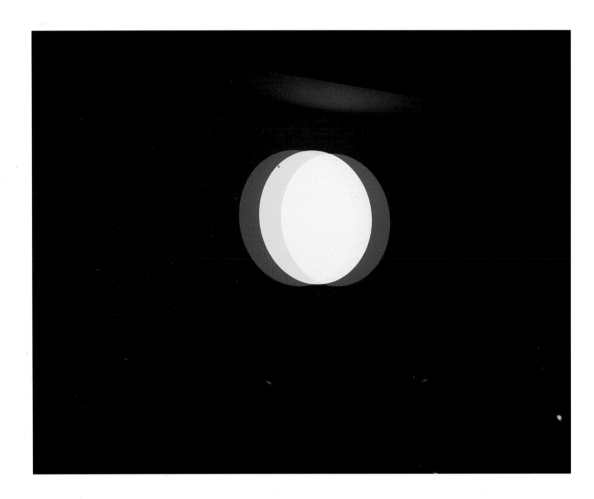

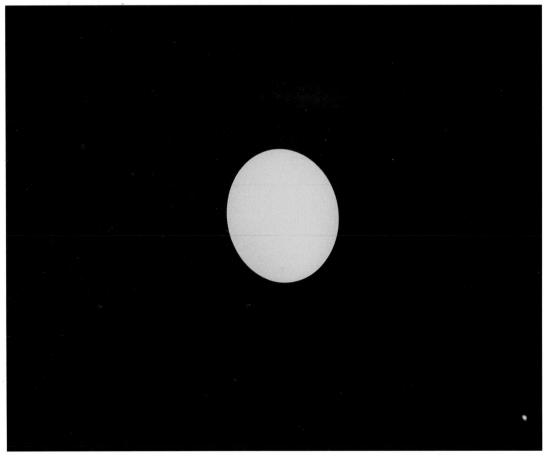

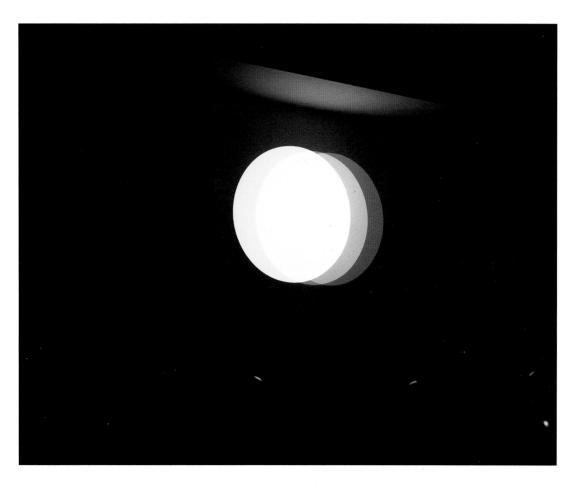

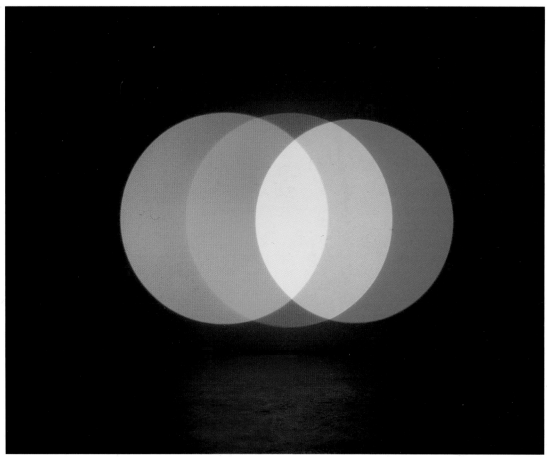

28. *Magic Lantern* (1987)

SM: What did you decide it meant?

SH: I don't know. In convinced me of the reality of the divided self, and that one person is many voices but there is no bounded unit who contains them. They could be seen as possibilities of being. We have ways to tune out most of them and tune in some. I suppose that when they become overwhelming, our society says you're mad or schizophrenic. This experience was not overwhelming in that way, nor was it sought for. Except you could say, 'Of course you sought it by going to France and working on an ESP piece (*Draw Together*, a postal event) in the first place'. There was nothing eerie about the experience. The most interesting part of *Sisters of Menon* was that it seemed to address itself to a kind of female sensibility or entity. When my husband tried to tune in on it, he produced a page that said something like, 'Go away, you are not the sister'. There are so many levels, ironies and little jokes, that you have to recognise something with an amazing sense of humour and a very quirky attitude. 'Menon' is 'no men' but I think it was Lucy Lippard who pointed out that it's also an anagram of *nomen*, which means 'name': the opposite of not having a name, in other words, sitting or situating the voices.

For a while it led me down strange paths; I thought I had to investigate all kinds of historical facts, for instance one of the Menon scripts says 'We are your sisters from Thebes'. Thebes is of course the necropolis in Egypt which undoubtedly I had already read about, and one famous precinct there is dedicated to someone called Memnon. I also got involved in reading about the Cathars because the village I was in was in their area of France and a circle with an equal-armed cross or X, which was a Cathar symbol, appears at a certain point in the scripts. Cathars followed a Gnostic tradition, which leads to interesting ideas about religion and gender. It all seemed to tie together.

Then at a certain point I realised that the scripts were a fragment and an irrational production; you could spend your life interpreting it but you wouldn't get anywhere. It was a question of accepting this production as a drawing as well as an utterance. The fact that it was a physical production became really important to me. And just to allow it to exist in whatever ambiguous placement it had – just to let it be – was also important. But it did link me with certain traditions pertaining to gender.

I became interested in secret languages, ritual languages, coded languages, artistic languages and in my own problem of finding what was called 'a voice', because the Sisters seemed to have so many voices.

SM: Do you think you lost the manuscript deliberately?

SH: I probably wasn't able to accept it immediately and to say 'Yes these messages or utterances are as important as any other'. It made me interested in art in a different way; I could see all the

trajectories through Modernism that had been considered unacceptable. You know, Surrealism was like a dirty word.

SM: Taken seriously, *Sisters of Menon* would result in a quite different view of culture.

SH: I see culture as a series of curtailments. The reason we value art is that despite this, it can provide occasional glimpses of different ways of perceiving and understanding.

SM: How do you see your own work?

SH: I never know whether it is one work or not. I'm aware there's probably the difficulty that one ends up with fragments as evidence of something.

SM: Or as attempts to reach a single place. That wouldn't be so terrible.

SH: Well, to regard *An Entertainment* (1990) for example as a totality would be completely misleading. It has been seen as a statement about child abuse or domestic violence. In fact, I'm interested in at least three things: one, the kind of mythic underpinning; two, the left/right dichotomy; three the eroticised violence, deeply scary but sexy at the same time. I understand the large works as incomplete and as much part of an ongoing procedure as the small works. Even the way *An Entertainment* is constructed: similar episodes with slight differences repeated and stitched together, different takes on comparable scenes, is like the small works. I would say the content of my work is consistent although the subject matter of different pieces varies a lot.

SM: The way I see it, in a piece like *Magic Lantern* (1987), is that you are suggesting that a mental area exists in which creation happens, whether you are the creator or the audience, that here is a zone in which it is possible to release your imagination or use it in some way, and you're asking 'Can we talk about this?' In other words, can we consider this area within which anything is possible because it's not real? (Though to us it's very real within certain boundaries.) It's like what happens on a stage or when a storyteller says, 'Once upon a time..' then everything after that is modified until the end.

SH: I like your notion of a zone, but you see, to me that zone is totally real, and *Magic Lantern* is one of the clearest, strictest, most direct statements of this I've ever made. I'm showing you – and showing myself, because it's a machine I can use too – that the perceptions of the body and the effect of light on the eye, the intersection of the body and desire, creates beauty, creates meaning. That piece can't be documented because the colours you're seeing are real but invisible externally. So it's specific to you but it's also collective because it happens to all of us in the audience at the same time. It's not unreal, that's what I want to emphasise. Just like the shapes people see in my video *Belshazzar's Feast* (1980–81) are as real as anything else. I think you mean they're not real if they're not objectively there or not outside us? What do you mean?

SM: The idea of an invisible stage, the reaction that Coleridge called 'the willing suspension of disbelief' and how this can be maintained or cut off. If you suddenly start quoting Shakespeare I can tell if you're quoting even if I've not read Shakespeare.

SH: The only time I've emphasised that is in *An Entertainment*. When the curtain goes down you're really stranded after you've been up in the stars, and it's like asking a question about how we are intersections of these possibilities, consensus reality and these states where we experience other things. In that work the story just ends; the curtain comes down. Pieces like *Belshazzar's Feast* and *Magic Lantern* don't end so abruptly; you can still see after-images for a while. We're usually not aware that everything we perceive is a combination of something externally given and something we bring to it so there is never anything without our subjectivity. What I want to make is situations where people are aware what they're seeing is because of who they are; so they are conscious of the fact they are part of a mechanism for producing pleasure and pain, that we're not just walking through life as though it were someone else's film. It's like dreaming: you're both inside and outside and it's important to *know* you're in both places.

SM: How does that help in *An Entertainment*? It's disturbing. It's all around me. The figures of Punch and Judy are bigger than I am. People are being beaten, the change of size is tremendous. For someone who had never seen a Punch and Judy show, I'm not sure what it would mean.

SH: I don't know either. My work is particular to this culture. All rituals are scary. Part of what art is about now is to find ways of beginning to say things about the darkness of the culture. The piece is not intended to be an admonition; it was meant to be the experience of a child. I was subjecting myself to what I saw children being subjected to with every Punch and Judy show. Yet at the same time, adults find these little figures hitting each other strangely jolly. The child is just a little person who has the problem of fearful identification at the same time as being told it's enjoyable. The child is being taught something through the terror of ritual, and the hope of the male child is that he will become Mr Punch. Girls see it differently. After seeing my piece, I think everyone does.

SM: Are we meant to identify with Punch because he is the protagonist?

SH: It's a way to avoid being killed.

SM: What kind of ritual is it? What does it mean? There's a man, wife and child. He murders them all, is sentenced and then kills his judges too.

SH: You can't explain it in those terms: it's not a story about a man who does good or evil. He's not a man, he's Mr Punch and he's not human. He's monstrous, even his voice is distorted through that funny little thing…

SM: A swazzle.

SH: To deform voice as well as body. The curious thing is how this character came to stand for Britain.

SM: Presumably Punch and Judy was not English originally.

SH: *Commedia dell'arte* characters were brought to England by Italian showmen, who produced first, marionette plays, and later, glove puppets, which improved the fights: you can pit your right hand against the left so well. That's where English Punch and Judy differs from other versions which are played by marionettes. In the 18th century, one Italian showman in London reduced it to a series of simple stick fights.

SM: You think a lot about this left/right dichotomy.

SH: It's a universal distinction. (Of course, the left hand refers to the right part of the brain and the right hand to the left part). The right hand is seen as good, dominant, clean, and worthy, the left sinister, gauche, dirty. As society becomes increasingly rational we've tended to downgrade the intuitive. Punch and Judy puts Punch on the puppeteer's dominant right hand – and all the other characters, women, children, animals, death – on the intuitive, denigrated left. As in ancient myth it reduces to a dualism, which may refer as much to these opposed parts of our brain and body as to anything socio-historical. I find that pretty interesting.

Commissioned by *Frieze* magazine and first printed in *Frieze* 23, Summer 1995.
Reprinted by kind permission of the editors.

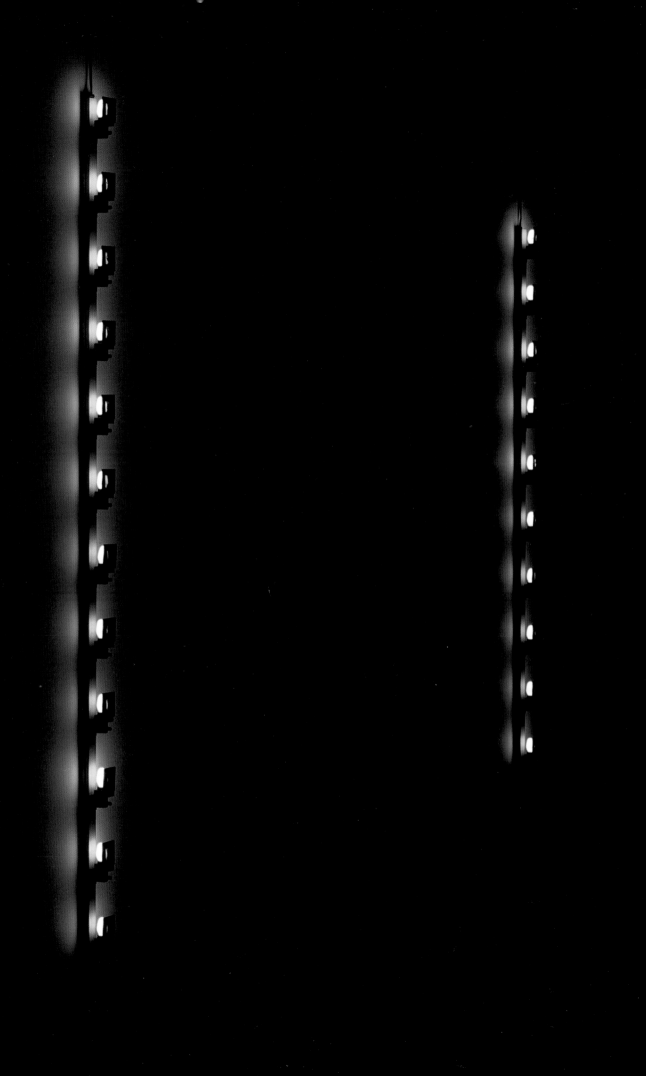

32, 34, 35. *Child's Play* I, II, III (1991–92)

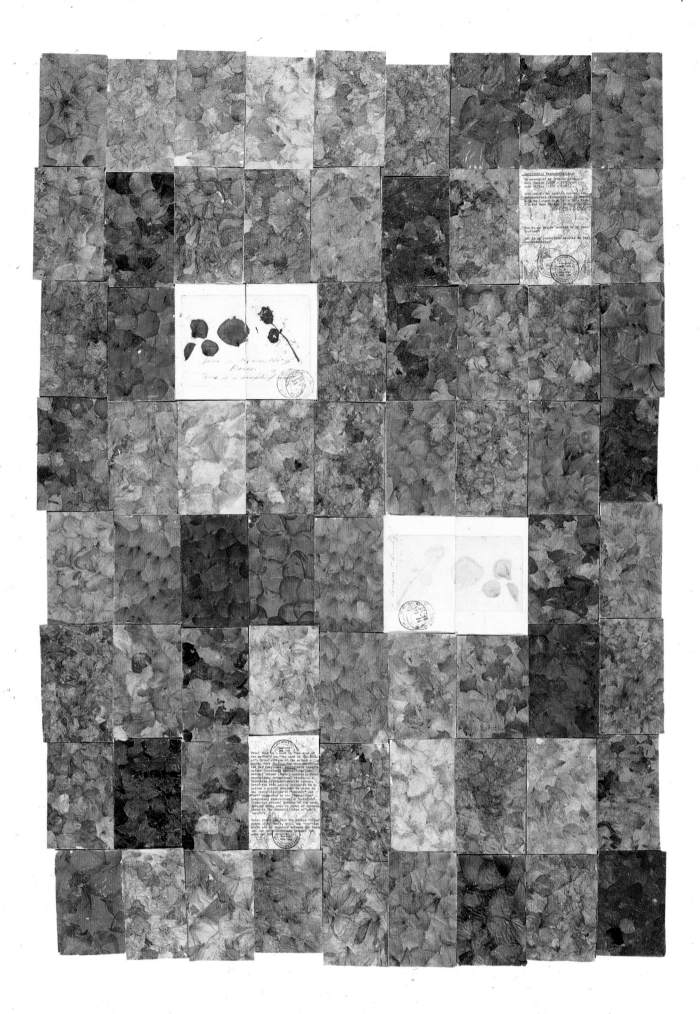

48

22. *Sentimental Representations in Memory of my Grandmothers (Part I for Rose Ehrich)* (1980–81)

CATALOGUE

This catalogue has been written by Rebecca Dimling Cochran in close consultation with Susan Hiller. The exhibition does not cover all aspects of the artists work. The catalogue gives information on the pieces shown in the exhibition and where relevant, works which are not in the exhibition have been briefly mentioned. The catalogue divides the work into four sections – Group Investigations, Recycled Works, Automatic Writing and Memorials. It includes information on the production, exhibition and critical reception of all the works in the exhibition. Information has been drawn from published sources, from conversations with the artist, and from the artist's unpublished notes. The current location of works in public collections is indicated.

1. GROUP INVESTIGATIONS

Dream Mapping

Enquiries/Inquiries

Between 1969 and 1974, Susan Hiller began to develop a series of performance-based works that bridged the gap between the 'event-orientated' and 'object-orientated' approaches to art practice prevalent at the time. She called these works 'group investigations', positioning the participants as collaborators responsible for creating the works and their resultant end products or documentation. In most cases, participants took individual experiences that are usually private and relocated them in the public realm in ways that demonstrated their communality. Hiller describes her approach in the catalogue to the exhibition *About Time* at the ICA in 1980:

> The works… are deliberately non-theatrical. They are conducted among creative equals in the spirit of a collective endeavour, for which all participants are responsible… Individual experiences, reactions, and expressive acts function as aspects of a structure… designed to intensify a sense of shared subjectivity.

Dream Mapping is related to several earlier 'group investigation' projects. Hiller's first video work, *Pray/Prayer* (1969) used the new medium of video to investigate and record modified behaviour with a selected group. In *Draw Together* (1972), Hiller conducted an exploration of the telepathic transmission of images by producing simultaneous drawings with artists in other countries. For *Street Ceremonies* (1973), the artist and more than 200 invited participants marked the geographical and social boundaries of a London neighbourhood by performing with mirrors at noon and candles at sunset on the autumn equinox. Super-8 film and audio documentation created by the participants survive, together with the artist's notes, numerous photographs and other documents of the event. In 1974, in conjunction with the writer David Coxhead, Hiller published the book *Dreams: Visions of the Night*.

Street Ceremonies (1973)

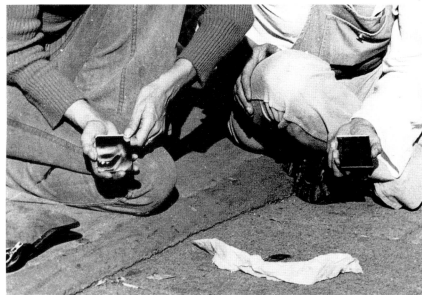

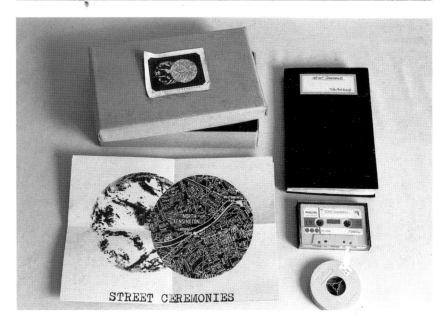

Street Ceremonies (1973)

Draw Together (1972), letter of invitation

16. Dream Mapping

(1974)

EXHIBITIONS:

1986 *Susan Hiller: Out of Bounds*, ICA, London

PUBLICATIONS:

Brett, Guy, Parker, Roszika and Roberts, John, *Susan Hiller: The Muse My Sister*, Derry, London, Glasgow, 1984

Einzig, Barbara (ed.), *Thinking About Art: Conversation with Susan Hiller*, Manchester, 1996

Goldberg, Rose Lee, *Performance: Live Art 1909 to the Present*, London, 1979 (reprinted as *Performance Art: From Futurism to the Present*, 1988)

Hiller, Susan, 'Dream Mapping', *New Wilderness Newsletter* 10, Winter 1981

Hiller, Susan, '10 Months, 12 Years', *About Time: Video, Performance and Installation by 21 Women Artists*, London, 1980, illus.

Lippard, Lucy, *Susan Hiller: Out of Bounds*, London, 1986

Lippard, Lucy, *Overlay: Contemporary Art and the Art of Prehistory*, New York, 1983, pp.160–161

Sharkey, John, 'In Pancake Making, It's the Mix That's Important', *Musics* 9, September 1976

The previous year, while working on the book, she conducted a group investigation into the 'origin of images and ideas' called *The Dream Seminar* (1973). In this work, twelve participants met for twelve weeks to discuss their dreams and their subconscious interaction or 'dream meetings', documenting their progress in notes and audiotapes.

For **Dream Mapping**, Hiller invited 10 participants to develop a graphic system of recording their dreams. Then, for three nights, they all slept outdoors in an area of the Hampshire countryside with an unusual occurrence of fairy rings, or circles formed by the marasmius mushroom, chosen because of the myth that if you sleep within one of these circles, you can enter fairy-land. Each participant was given a notebook with a map of the dream site on the cover. Every morning they recorded their dreams using the system of note-taking that they had developed earlier. They noted the similarities and differences among the dreams by the making of collective dream maps, in which they took all of the individual diagrams from each day and superimposed them to create a group notation.

For her solo exhibition at the ICA in London in 1986, Hiller evolved a form of presentation for this material, displaying the open notebooks in individual vitrines, and reproducing a considerable number of the participants' dream maps and diagrams as large wall drawings.

In summing up this period of Hiller's work in *Musics* magazine in 1976, John Sharkey wrote:

> No role is allocated to an 'audience'. The participants are passive and active in both the viewing and participating sense, and what occurs among the group is an enactment or, more appropriately, an enacting, of the work… The artist is a participator, as well as the originator, of all her projects. Once the over-all form has been set… she is happy to move into the background and as participant take part in the realisation of the work… Susan Hiller's original approach combines various roles, as artist, in giving form to an amalgamation of ideas, as producer in organising people and finance, as a participant in the actual work, and documenting the outcome… [The dream maps] are art(ifacts) showing the process of art through dreaming. They 'belong' to the artist only insofar as they provide a record of the group adventure…

Hiller's early 'group investigations' had the inherent problem of reaching only those who were either invited to participate or who saw the resultant documentation.

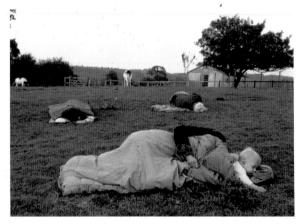

16. *Dream Mapping* (1974)

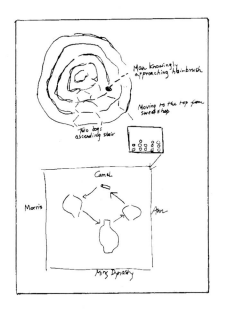

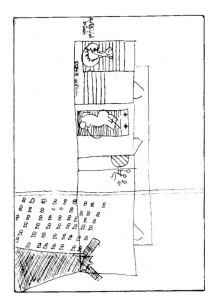

The Garden
(The Men's House, 3)

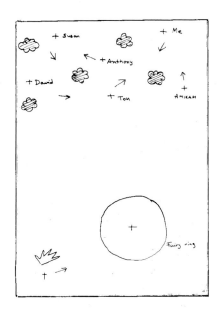

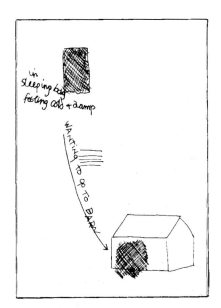

Dream maps

Next pages:
5. Enquiries (1973-75)

Can stars be seen in the daytime from a well?

The popular belief that stars and planets can be seen in the daytime from the bottom of a well or shaft is true only to a very limited extent. A person observing the stars in daylight is assisted by a shaft or tube in two ways. The pupil of the eye is protected from stray light and lateral illumination. If transfused light can be cut off the acuteness of vision is considerably increased in the straight line of the tube. Thus it happens that occasionally an observer at the bottom of a well, mine shaft, silo or canyon is able to see planets or bright stars at midday. It is commonly said that there are about twenty stars of the first magnitude that are bright enough to be detected by the unaided eye looking from the bottom of a well or pit. The Yerkes Observatory, however, is of the opinion that in most cases where stars and planets have been seen in this manner they could have been seen without the assistance of a well or shaft, provided the eye had been protected from stray light. For several weeks every year the planet Venus can be seen at any hour of the day with the naked eye if the observer knows where to look. But it can be seen somewhat better if the observer stands in the shadow of a tree or a portico in order to reduce the diffuse light.

417. *What causes the twilight ?*

The phenomenon of twilight is due partly to refraction and partly to reflection, but chiefly to the latter. After sunset the sun still continues to shine on the clouds and upper strata of the air, just as it may be shining on the summits of lofty mountains long after it has disappeared from the view of the dwellers on the plains. The air and clouds thus illumined reflect back part of the light to the surface beneath them, and so produce what we call twilight. Immediately after sunset the clouds are so highly illuminated as to be able to reflect an amount of light but little inferior to the direct light of the sun. As the sun sinks lower, less and less of the visible atmosphere receives its light, and so less and less is reflected, until at length reflection ceases and night ensues.

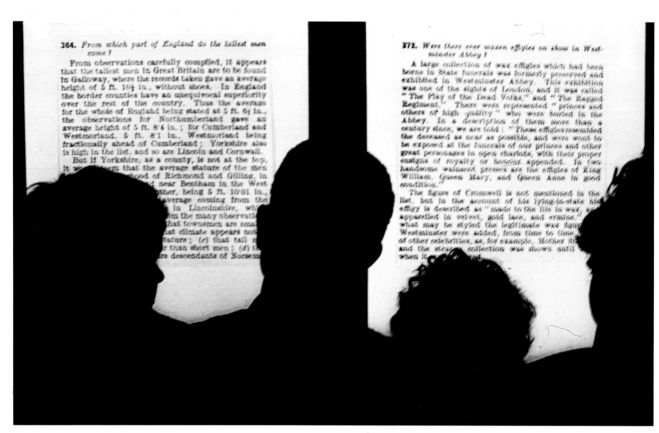

Enquiries (1973), first showing

5. Enquiries/Inquiries
(1973–75)

EXHIBITIONS:

Enquiries only:

1973 *Three Friends*, Gallery House, London
 (under pseudonym Ace Posible)

1974 Royal College of Art Gallery, London

Enquiries/Inquiries:

1975 *Enquiries/Inquiries*, Gardner Centre for the
 Arts, University of Sussex, Brighton
 Enquiries/Inquiries, St Martin's School of Art
 Gallery, London

1976 *Six Times*, Serpentine Gallery, London

1977 *Kunstlerinnen International*, NGBK, Berlin

1978 *Susan Hiller: Recent Works*, The Museum of
 Modern Art, Oxford; Kettle's Yard,
 Cambridge

1984 *Susan Hiller: Ten Years Work*, Third Eye
 Centre, Glasgow

PUBLICATIONS:

Brett, Guy, Parker, Roszika and Roberts, John,
 Susan Hiller: The Muse My Sister, Derry,
 London, Glasgow, 1984

Einzig, Barbara (ed.), *Thinking About Art:
 Conversation with Susan Hiller*, Manchester,
 1996

Elliott, David, Faure Walker, Caryn and Hiller,
 Susan, *Susan Hiller: Recent Works*, Oxford, 1978

Faure-Walker, Caryn, 'In the Beginning was the
 Word: Susan Hiller's Recent Work', *Artscribe*
 5, February 1977

Hiller, Susan, *Enquiries/Inquiries*, broadsheet,
 Serpentine Gallery, London, 1976

Hiller, Susan, *Enquiries/Inquiries*, Brighton, 1979

Enquiries/Inquiries marked Hiller's relocation into the realm of more traditional art galleries and museums. Originally created and exhibited as a single, complete work, the British **Enquiries** was made in 1972–3. The American **Inquiries** was added in 1975. Hiller describes the creation of these parallel works in a broadsheet published by the Serpentine Gallery in 1976:

> In 1972 I came across a book called *Everything Within: A Library of Information for the Home*. Particularly fascinating, although incomplete, was the chapter entitled 'Questions and Answers', which promised 'to throw light on problems of the utmost interest in every imaginable direction, from classical days to our own times'.
> I began to think of the material as the basis for a slide piece, suspecting it would indeed 'throw light… in every imaginable direction', if these fragments of culturally accepted reality ('facts') could be held up as images for collective contemplation… **Inquiries** developed almost exactly two years later, when on a rare visit to the United States, I was presented with a battered American book of the same sort.
> Ordinary matter-of-fact 'facts' are extremely strange. 'Facts' are not just reports about an outside world, but also about our relation to that world… because the way we describe the world is the way it somehow is. When numbers of people share a language, they agree about the 'facts' and they can then be said to be a cultural unit. Being able to agree about 'facts' implies basic agreement about the definition of a 'fact', about where its boundaries are, about what its nature is, etc. – in other words, agreed theories about the nature of reality.

One hundred 'facts' were selected from each encyclopaedia. Excerpts from the British version were photographed in daylight using film made for artificial lighting, causing the slides to have a faint amber tone while the American slides were photographed with daylight film under artificial lighting, resulting in a green tone. The subtle colour discrepancy is repeated in the neon title that accompanies the piece, which was created using typefaces that reflect the origin of the 'facts' – *Kensington* for **Enquiries** and *New York* for **Inquiries**.

In **Enquiries/Inquiries** Hiller reversed the approach she had used for her earlier participatory works. Rather than start with the individual and search for collectivity, she used cultural artefacts as her basic materials, and from them sought individual interpretation. In this and many subsequent works, Hiller aimed to reveal the overlooked or repressed meaning of ordinary things. As Caryn Faure Walker explains in an article for *Artscribe* in February 1977:

> As information, the world can be pictured communally, but only its surface… **Enquiries/Inquiries** scatters details covering everything from a petrified pebble to the names of important persons, arranging, it seems, a place for everything on this earth. But Hiller negates such categorisation by showing simultaneously pairs of definitions that make nonsense of each other. Between the work's surface representing the factual world and that surface made visible lies the essential pun. In **Enquiries/Inquiries**, we gain insight into the world by our participation in its re-ordering of sight. The work scrutinizes the meaning of the 'presentable' world of facts through the slide projector's mechanical eye. Through the translucent surface of the slides our eyes begin the process of seeing other possible worlds of meaning. We move towards enlightenment, from the mechanical to the preternatural powers of light.

2. RECYCLED WORKS

Hand Grenades

Measure by Measure

Painting Blocks

Big Blue

In 1972 Hiller left her studio in Alexander Street and began a series of recycled works created from the raw elements of earlier pieces. Although differing in materials and construction, all these objects emphasise Hiller's archaeological interest in 'cultural relics', and her continuing fascination with transformation. In the interview with Stuart Morgan in this publication, Hiller describes them as 'traces or remnants, they point forwards and backwards at the same time'.

1. Hand Grenades

(1969–72)

EXHIBITIONS:
1994 Gimpel Fils Gallery, London

PUBLICATIONS:
Archer, Michael, 'Interview with Susan Hiller',
 Audio Arts Magazine 4, no 1, audiocassette,
 1994 (cover illus.)
Corris, Michael, *Susan Hiller's Brain*, London,
 1994
Lillington, David, 'Susan Hiller, Gimpel Fils',
 Time Out 27 April–4 May, p.44

The first works in the series evolved from a large bonfire Hiller held to dispose of works she did not intend to move to her new studio. She took the resulting ashes and placed them in chemical containers which she labelled with reference to their original status. *Collected Works 1968–1972* consists of a test tube containing ashes from various works, tagged with title of the work and the artist's signature. **Hand Grenades** was re-constructed from an investigation called *Hand Painting* (1969), in which several small groups of participants made collaborative paintings using only the imprints or outlines of their hands. The paintings were burned, and the ashes placed in small glass containers which Hiller refers to as either 'little bombs' (surprise) or 'light bulbs' (insight). As Michael Corris points out in his essay entitled *Susan Hiller's Brain*:

> By burning a number of paintings and then retaining their ashes in a slightly scientific archive, Hiller can be said to be clearing a cultural ground. Other artists have made a big deal about destroying their work. But Hiller's act is one of *transubstantiation* through immolation. This suggests that her orientation toward conceptual art is deeply consistent with her prior critique of anthropology. In both cases, we are confronted with a 'remainder' and left searching for the meaning of a cultural practice which comes to us in utterly fragmented material form or as a transient moment in our life-world.

Hand Painting (1969) – original painting for 1. *Hand Grenades* (1969–72)

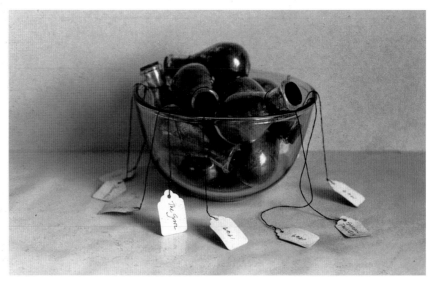

1. *Hand Grenades* (1969–72)

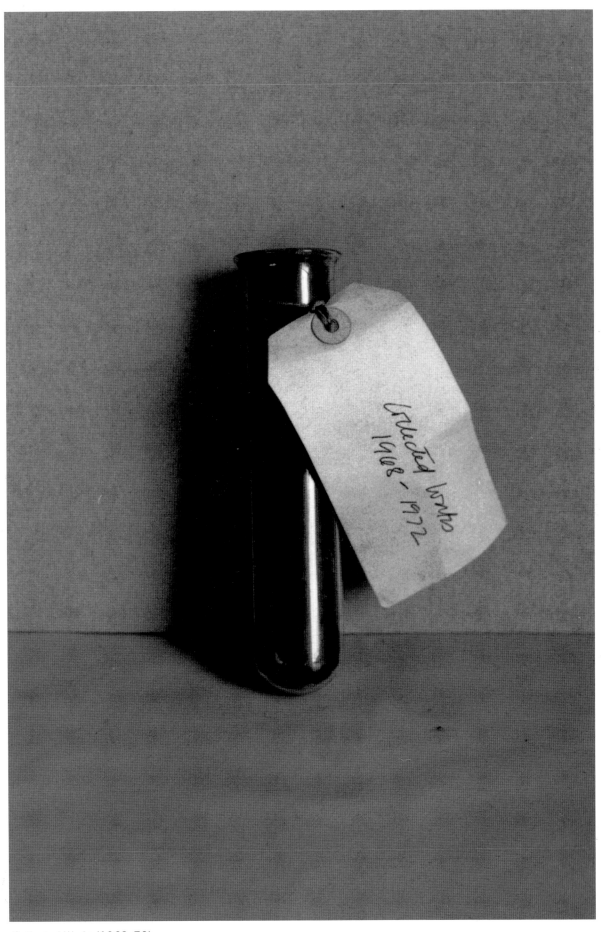

Collected Works (1968–72)

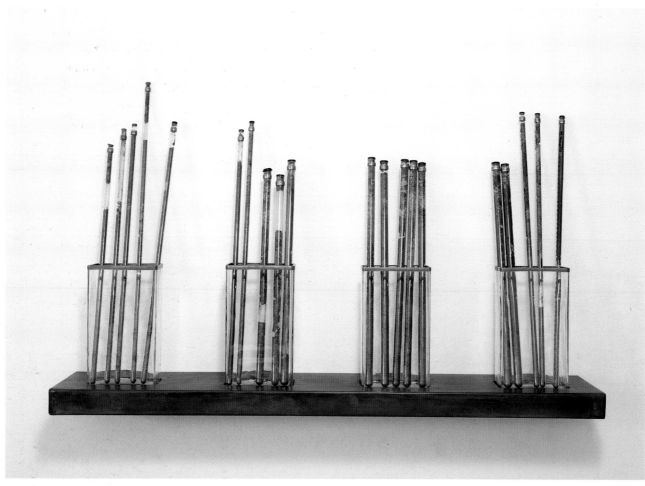

15. *Measure by Measure* (1973–92)

15. Measure by Measure
(1973–92)

EXHIBITIONS:
1994 Gimpel Fils Gallery, London

PUBLICATIONS:
Corris, Michael, *Susan Hiller's Brain*, London,
 1994.

Hiller continued the series a year later when she burned several canvases in a small
private bonfire in the yard of The Dairy where she had her studio from 1973 to 1976.
The remains became *Recent Work 1972–1973*, which consists of ashes housed in
laboratory-like containers and tagged with title, date and signature. **Measure by
Measure** also began in 1973, when Hiller burned one large canvas that had been
returned from an extended loan badly soiled. Thus she began a process of burning
roughly one work a year which she then placed in a glass measuring burette and
labelled with the title and date of the original work. As Hiller states, 'The idea of
measuring seems related to my interest in assessing the relative importance of
material and immaterial properties of objects. It also has to do with measuring time —
a contradiction. But this project gives each year a weight, or a measurement'. In
1992, to mark 20 years of the project, Hiller assembled the individual burettes in
their current configuration. The series is ongoing.

2, 7, 8, 9, 10, 11, 12, 13, 14. Painting Blocks

(1973–84)

EXHIBITIONS:

1980 *Susan Hiller: Work in Progress*, Matt's Gallery, London (nos.1–6)

PUBLICATIONS:

Fisher, Jean, *Susan Hiller: The Revenants of Time*, London, Sheffield, Glasgow, 1990, illus.

Renton, Andrew, 'In Conversation with Susan Hiller', in Searle, Adrian (ed.), *Talking Art*, ICA Documents 12, London, 1993, pp.85–99

Swayne, Chris, *Susan Hiller: A Provisional Portrait*, London, 1990, 16mm film, colour, 17min.

Hiller also recycled her two-dimensional paintings into three-dimensional sculptures which she called **Painting Blocks**. Her first *Painting Block* was made from a canvas originally exhibited in 1968, which Hiller cut into 100 pieces and sewed together in a block shape that roughly conformed to the dimension of the original painting. A few years later, Hiller bound segments of her paper installation *Transformer*, first shown at Gallery House in 1973, into the second issue of *Wallpaper* magazine. Published in December of the following year, each of the 260 copies included a section titled *Transformation*, consisting of a photograph of the original installation of *Transformer*, a segment of the actual piece, and a hand-drawn map to locate the segment within the photograph.

In 1974, Hiller exhibited a series of works which provided the material and philosophical grounds for several subsequent projects. Alongside a series of drawings and paintings, she exhibited a work called *Format / Projection*, in which she projected a cycle of one hundred slides showing details of her paintings on a blank canvas that was stretched to conform exactly to the dimensions of a projected 35mm slide. Thus the viewer experienced the illusion of seeing a rapid succession of 'projected' paintings alongside the static 'real' paintings.

Transformer (1973)

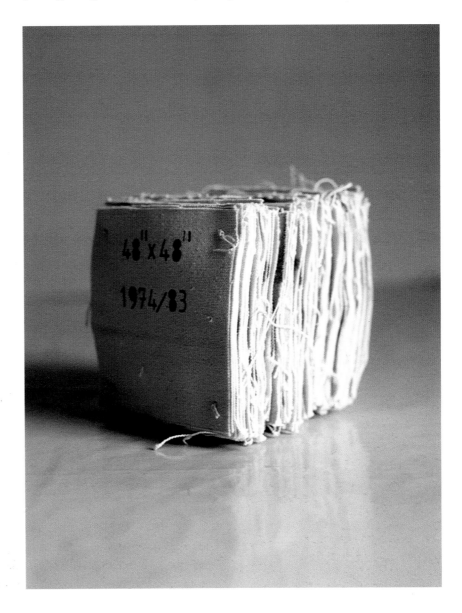

2. *Untitled* 1968–7? (*Painting Block*) (197?)

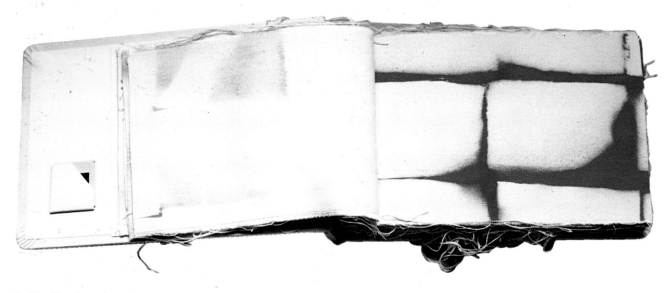

6. *Big Blue* (1973–76)

6. Big Blue

(1973–76)

EXHIBITIONS:

1994 Entwistle Gallery, London

In 1976, Hiller reassembled one of these 'real' paintings into a book made from cut-up segments of the original, and titled it *Big Blue*. A reference slide of the original painting was placed in a pocket inside the book's front cover. Although **Big Blue** was not exhibited until recently (on the twentieth anniversary of the exhibition of the original painting), it is closely related to a work entitled *References*, shown at The Store gallery in New York in 1975. For this installation, Hiller created a set of four books made from paintings, each of which, like **Big Blue**, contains a slide of the original. These books were placed on tables under reading lamps, surrounded by projections of the slides enlarged to the same size as the originals.

Other works from the 1974 exhibition were reconfigured for Hiller's 1980 exhibition *Work in Progress* at Matt's Gallery in London. For three weeks before the exhibition opened, Hiller worked in the gallery space creating pieces for the show. Visitors were invited to watch as she took apart a single canvas thread by thread and re-wove the resulting strands into *String Drawings* (1980). Six canvases were also transformed into **Painting Blocks** similar to the one created almost a decade earlier. Each block represented one of the years between their first showing and the current date. These were bound and stamped with a date and the dimensions of the original paintings. Subsequently, Hiller created one **Painting Block** each year through 1984, to complete the present series of ten blocks. As Jean Fisher wrote in *The Revenants of Time*:

> In the work's movement from the simple… to the multiple… the artist extends some of the procedures and values of an earlier minimalist aesthetic; a rejection of the autonomous, 'ideal' object in favour of non-hierarchical modules; the breakdown of traditional distinctions in painting and sculpture; and an experience of *making* or *duration*, encompassing the act of viewing, that reinstates a more interactive relation between art and the body… In emphasising **duration**, *Work in Progress* enacted one of the primary heresies of the formalist canon… Its process is transformative; not loss of matter, but a change from one state of existence to another.

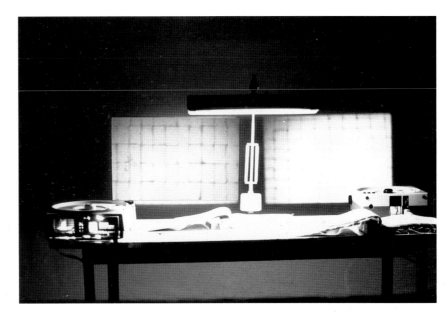

References (1975)

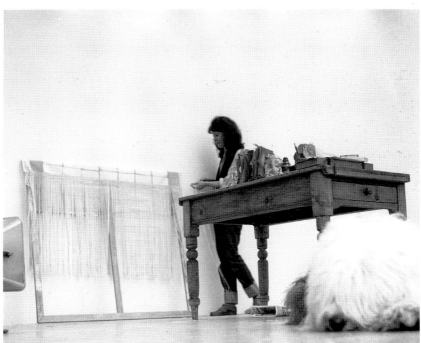

Work in Progress (1980)

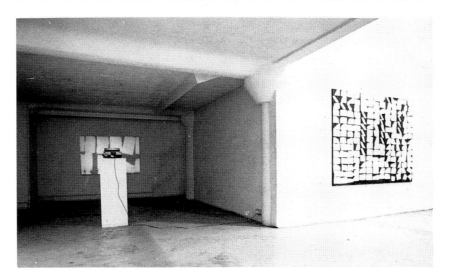

Format/Projection (1980), left

Original painting for 6. *Big Blue*
(1973–76), right

3. AUTOMATIC WRITING

Sisters of Menon

Mary Essene

My Dearest

So Don't Let it Frighten

Get William

Bad Dreams

Lucid Dreams I, II

Belshazzar's Feast

The Secrets of Sunset Beach

Magic Lantern

Automatic writing

Hiller has used different forms of automatic writing for over twenty years. Originally a drawing exercise, she has transposed this method of mark-making onto photographs, wallpaper and canvas. Often she lays the marks directly on the surface, at other times she projects them onto objects or environments and creates new works from the result.

A constantly evolving series, Hiller's automatic writing works began in 1972 while she was staying in a small town near Sète, France. She describes her discovery of the technique in her 1983 book, *The Sisters of Menon*:

> I had been working on a project called *Draw Together*, a group investigation into 'the origins of images and ideas'. One evening after completing a section of the project, I picked up a pencil and began to make random marks on a blank sheet of drawing paper. At first the marks formed what looked like childish letters I could not decipher. Then coherent words began to appear. The pencil seemed to have a mind of its own and wrote page after page of text in an unfamiliar style... Here my spontaneous scribbling ended up as writing. In later examples, writing dissolved into marks that look like crypto-linguistic, calligraphic signs... Perhaps the last word in the **Sisters of Menon** scripts provides a clue, for the ancient Greeks (I'm told) had only one term for writing and drawing.

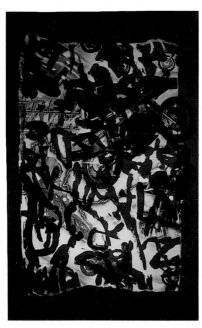

Home Truths (1990)

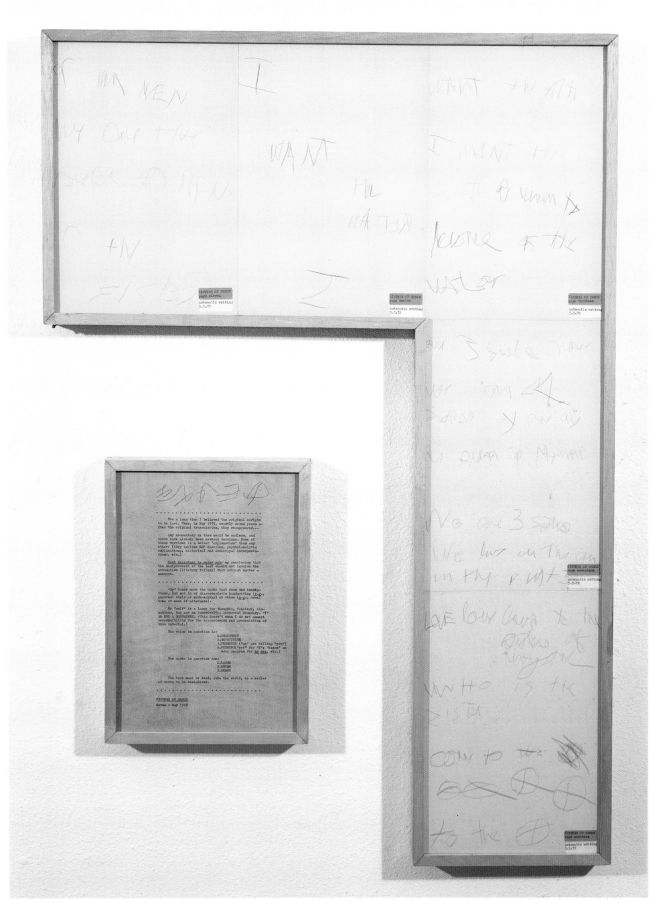

4. *Sisters of Menon* (1972–79), detail

who is this
one/I am this
one/Menon is

(1)

Menon is
this one/you
are this one/

(2)

I am the sis-
ter of Menon/I
am your sister/the
sister of — of ev-
eryone's sister/I
am Menon's sister

(3)

— I live in
the water/I
live on the
air/

(4)

I am — the
sister/love
o my sister/

(5)

the woman is
the sister/a
man is the
mother of
the sister/

(6)

eye eye eye
eye I live my
sister/

(7)

— — — — —
— — — — — —
Want-RO zero
is the silly
morse/is the
sister of
sister of

(8)

Menon/ we
three sisters
are your sis-
ter/this is
the nothing
that we are/

(9)

the riddle
is the sister
of the zero/
we are the
mother

(10)

of men/we are
the sister of
men/o the
sisters

(11)

I want the
water/I

(12)

want the air/
I want the
sister of Men-
on to become
as the water/

(13)

will you be-
come my sis-
ter/

(14)

I am the
sister of
everyone/I
am your sis-
ter/we 3
sisters are

(15)

1 sister/
you are
the sis-
ter/last
night we

(16)

were 3 sisters
now we are 4 sisters/
you are the sister
of Menon/we are 3
sisters/we live on
the air in the water/

(17)

we are the
sisters of Menon/
everyone is the
sister/I am the
sister/love oh
the sisters/

(18)

love love love
to the sisters
of everyone/
who is the sis-
ter/come to
the sun to the
s

(19)

— — — — —
we are your
sisters
from Thebes
Thebes/

(20)

Translation 5.79 &
Installation Notes

—SISTERS OF MENON—

4. *Sisters of Menon* (1972–79), detail

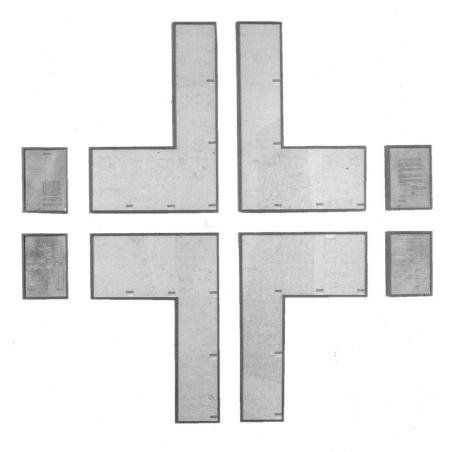

4. *Sisters of Menon* (1972–79)

4. Sisters of Menon

(1972 – 79)

EXHIBITIONS:

1974 *Have Artists Discovered the Secrets of the Universe?*, Artists Meeting Place Gallery, London

1980 Gimpel Fils Gallery, London

1981 *New Works of Contemporary Art and Music*, Fruitmarket Gallery, Edinburgh

1984 *Susan Hiller: New Work*, Orchard Gallery, Derry; Gimpel Fils, London; Third Eye Centre, Glasgow

Sensations of Reading, London Regional Art Gallery, Ontario

1986 *Susan Hiller: Out of Bounds*, ICA, London

Between Identity and Politics: A New Art II, Gimpel Fils Gallery, London

PUBLICATIONS:

Brett, Guy, 'Susan Hiller', *Art Monthly* 3, March 1980, pp.15–16

Brett, Guy, Parker, Roszika, Roberts, John, *Susan Hiller: The Muse My Sister*, Derry, London, Glasgow, 1984

Fisher, Jean, *Susan Hiller: The Revenants of Time*, London, Sheffield, Glasgow, 1990

Hiller, Susan, *Sisters of Menon*, London, 1983

Hiller, Susan, 'The Sisters of Menon 1,2,3' *Wordsworth* 2, no.1, Spring, 1995 (originally accepted for publication 1982), cover, pp.33–42

Lippard, Lucy, Hiller, Susan, *Susan Hiller: Out of Bounds*, London, 1986

Nairne, Sandy, *State of the Art: Ideas and Images in the 1980s*, London, 1987

New Works of Contemporary Art and Music, Edinburgh, 1981

Hiller exhibited the drawings a few times but it was not until 1979, when she re-discovered the stack of papers in her studio, that the present configuration of **Sisters of Menon**, complete with notes, was created. Guy Brett describes the piece in 1980:

These sheets, crudely marked with words in a straying blue pencil, are mounted on four L-shaped sections to form a cross on the wall, with four pages of cloudy-blue paper with typewritten notes placed on the wall on either side... The work presents a mystery. But in this piece, Susan Hiller does not try to solve the mystery in terms of what the words mean, or where they 'come from'. She used it as a device stimulus to reflect on her life from several directions. For example: how is one defined as an individual person? Where are one's edges and limits?

18. Mary Essene

(1975–81)

19. My Dearest

(1975–81)

20. So Don't Let it Frighten

(1975–81)

21. Get William

(1975–81)

EXHIBITIONS:

1982 *Susan Hiller*, Gimpel Fils Gallery, London
Andre Emmerich Gallery, Zurich
1986 *Susan Hiller: Out of Bounds*, ICA, London.

PUBLICATIONS:

Gooding, Mel, 'McKeever, Hiller', *Art Monthly*, Dec/Jan 1987, p26
Lippard, Lucy, Hiller, Susan, *Susan Hiller: Out of Bounds*, London, 1986

19. *My Dearest* (1975–81), detail

Hiller continued her automatic writing on paper in 1975. **Mary Essene**, **My Dearest**, **So Don't Let it Frighten** and **Get William**, vary in legibility, number of pages and configuration of those pages. As in **Sisters of Menon**, the commentaries on each work were added later, and these too differ in colour and placement.

Hiller has also used automatic photobooth machines to capture the illusive.

In 1969, attracted to the 'filmic and episodic' aspects of the images these machines produce, Hiller began a series of *Photomat Portraits*. These small, works were widely exhibited. They include self portraits, and a series of pictures of the artist and others called *Incognito*. In this series the sitters are disguised. In 1982, Hiller began the *Midnight* series of portraits which combine automatically produced photobooth images with Hiller's own, subjectively produced 'automatic writing'. Often the portraits were hand-coloured or collaged with wallpaper, feathers or other materials before being enlarged to their final dimensions.

In *Art Monthly* in 1987, Mel Gooding emphasizes the underlying connections between Hiller's automatic writing works, the photobooth portrait works, and the dream works:

> …In the early work – the presentation of automatic scripts such as *Sisters of Menon* and *Get William* and in the dream collaborations brought together in *Dream Mapping*… the direct evidence is set out in the form of the original hand-written scripts; in the case of the former with simple type-written transcriptions, in the latter with drawn enlargements of the original dream maps, in each case arranged in such a way as to suggest the non-linear, alogical nature of the messages… All of these various procedures have the effect of securing attention to the messages that the works exist to mediate and of eliminating the subjective presence, the personality, of the artist… Significantly, the *Photomat Self Portraits* disguise and deface her appearance, disclose only fragments of her face and body, and begin, in any case, with the 'work' of an automatic machine incapable of interpretation. The essential *agendum* (thing to be done) of her project is to establish… the multiplicity of our identity, to secure the knowledge that the individual self is a dynamic outcome of a process of representations, the meanings of which may in many cases be hidden from us… Art, like dreams, is a means of access to the largely unmapped space where the supressed, the forgotten and the unknown are to be discovered in order that they may be brought into and transform out waking discourse with reality.

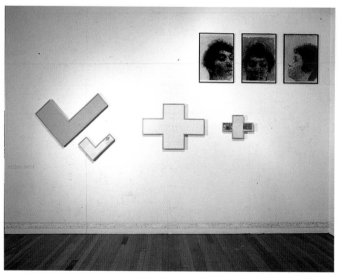

Installation showing, left to right, 20. *So Don't Let it Frighten* (1975–81), 21. *Get William* (1975–81), *Midnight Baker Street* (1983), ICA 1976

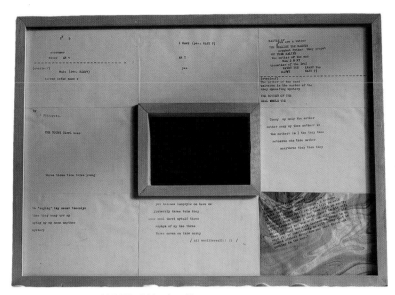

18. *Mary Essene* (1975–81), detail

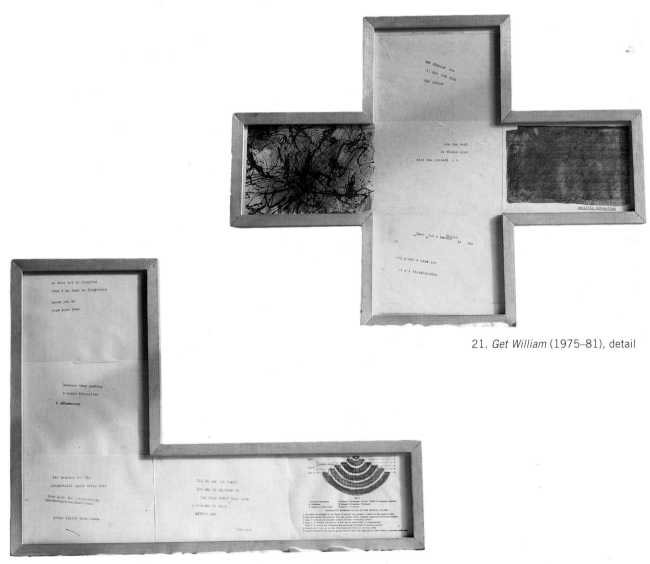

21. *Get William* (1975–81), detail

20. *So Don't Let it Frighten* (1975–81), detail

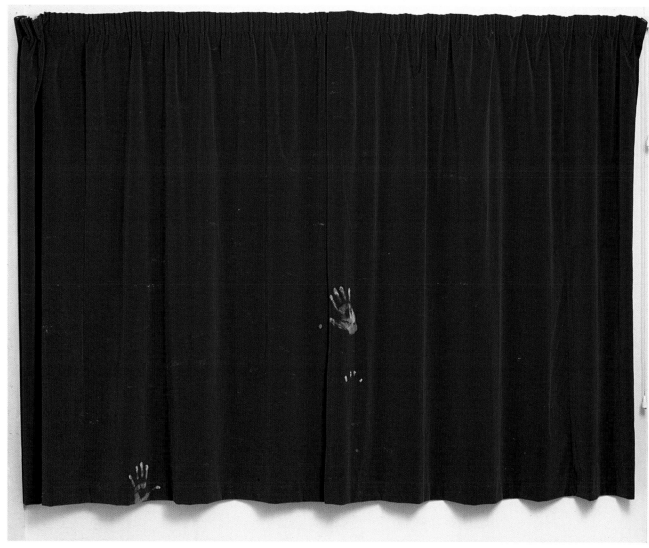

24. *Bad Dreams* (1981–83)

24. Bad Dreams

(1981 – 83)

EXHIBITIONS:

1984 *Susan Hiller: New Work*, Orchard Gallery, Derry; Gimpel Fils, London; Third Eye Centre, Glasgow

1985 *Walking and Falling*, Plymouth Art Centre, Plymouth; Kettle's Yard Gallery, Cambridge; Interim Art, London

1986 *Poetry*, Pat Hearn Gallery, New York

PUBLICATIONS:

Brett, Guy, Parker, Rozsika, Roberts, John, *Susan Hiller 1973–1983: The Muse My Sister*, Derry, London, Glasgow, 1984

Newsom, Gina, *Imaginary Women*, Channel 4 Television, 3 July 1986

Empty space and disembodied limbs characterise her **Bad Dreams** and **Lucid Dreams** series, both completed in 1983. Hiller describes her approach to these works in *The Muse My Sister*, published by the Orchard Gallery, Derry in 1984:

> In **Bad Dreams** and **Lucid Dreams** I'm trying to erode the supposed boundary between dream life and waking life. The work is clearly positioned in the waking world, since both pieces start off with photomat portraiture, but use the disconnected and fragmented images produced almost automatically by these machines as analogies for the kind of dream images we all know, for instance suddenly catching a glimpse of oneself form the back... It doesn't seem to me accidental that the machines produce this kind of image, because, as I've been saying for years about the popular, disposable imagery, there is something there beyond the obvious, which is why it is worth using in art.

Activating the normally passive curtain found in most photomat imagery used for 'official' identity pictures, Hiller employs the decorative fabric to introduce **Bad Dreams**. The mechanical drapes, stamped with the artist's handprint, unfold and a patchwork of hand-coloured photographs enlarged from photomat images is revealed. Woven throughout are grids of four words: each group was selected to represent elements of a bad dream about art which Hiller had previously recorded in a notebook.

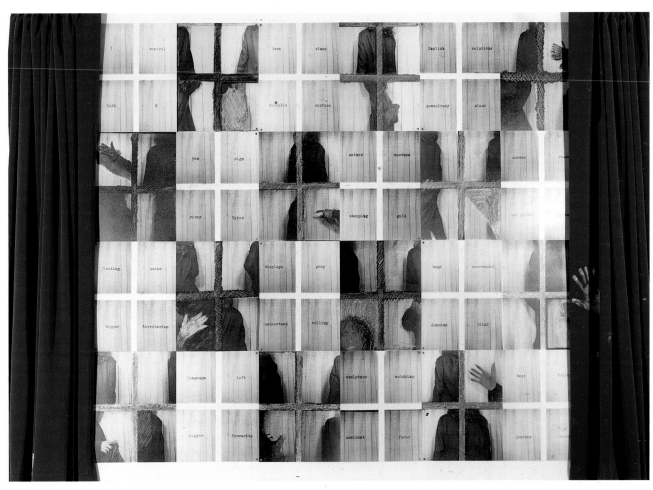

24. *Bad Dreams* (1981–83)

25, 26. Lucid Dreams I & II
(1983)

EXHIBITIONS:

1984 *Susan Hiller: New Work*, Orchard Gallery, Derry; Gimpel Fils, London; Third Eye Centre, Glasgow

1985 *Tolly Cobbold Eastern Arts Fifth Annual Exhibition*, Royal Academy of Arts, London; Fitzwilliam Museum, Cambridge; Christchurch Mansion, Ipswich; Cartwright Hall, Bradford; Laing Art Gallery, Newcastle upon Tyne (Lucid Dreams II)

PUBLICATIONS:

Brett, Guy, Parker, Rozsika, Roberts, John, *Susan Hiller 1973–1983: The Muse My Sister*, Derry, London, Glasgow, 1984

Hiller followed this work with **Lucid Dreams I, II,** *III, IV*. Although she continued her use of automatic writing in these works (**Bad Dreams** included none), she altered the process developed in the earlier photomat works, actually collaging the four panels of enlarged photographs onto a board, then working the surface. The effect is less finished, less pristine, more disjunctive. As John Roberts noted in the catalogue *The Muse My Sister*:

> The use of automatic writing and the automatic photograph (as forms which disolve the boundaries of object and subject), the pursuit of the dream-like in the waking image, are critical incursions rather than stylistic allegiances... Hiller uses unconscious material in her art as a means of disolving the unity of the self into the social ... Hiller's self-portraits are not interpretations or transcriptions of dreams. They are not fantasies. Rather, she projects herself as an image on a dream-screen. Her fragmented body becomes the dream process itself. Hence the idea of dreams being a convocation of fragments, a collection of psychic debris that needs 'working over' stands as an analogue of the self and language in waking life. The photomat portraits are thus metaphors of production, metaphors of new selves.

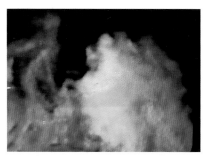

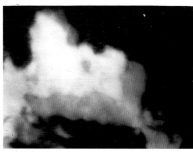

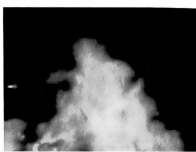

27. *Belshazzar's Feast* (1983–84)

Hiller's interest in automatic writing which proceeds directly from the subconscious, and in states of reverie or dream were extended in her video installation **Belshazzar's Feast/The Writing on Your Wall**. The main focus of this work is the video itself, which produces effects that enable viewers to enter a zone of liminality. Hiller described in her intentions for this work in a text published by the Tate Gallery in 1985:

> Nowadays we watch television, fall asleep, and dream in front of the set as people used to do by their firesides. In this video piece, I'm considering the TV set as a substitute for the ancient hearth and the TV screen as a potential vehicle of reverie replacing the flames.
>
> Some modern television reveries are collective. Some are experienced as intrusions, disturbances, messages, even warnings, just as in an old tale like *Belshazzar's Feast*, which tells how a society's transgression of divine law was punished, advance warning of this came in the form of mysterious signs appearing on the wall.
>
> My version quotes newspaper reports of 'ghost' images appearing on television, reports that invariably locate the source of such images outside the subjects who experience them. These projections thus become 'transmissions', messages that might appear on TV in our own living rooms.
>
> Like the language of the flames ('tongues of fire'), and the automatic scripts ('writing on the wall'), these incoherent insights at the margins of society and at the edge of consciousness stand as signs of what cannot be repressed or alienated, signs of that which is always and already destroying the kingdom of law.

Like the prophet Daniel, who could interpret but not read the mysterious writing on Belshazzar's wall, viewers only glean hints of revelation from the segmented soundtrack. Hiller whispers newspaper reports of foreign beings seen on television screens after station close-down. Interspersed with this she sings in an improvisational style similar to her automatic writing, and her son Gabriel describes from memory the Bible story of Belshazzar's Feast and the Rembrandt painting of the same name. The constantly running flickering flames were originally shot on super-8 film at a Guy Fawkes bonfire and subsequently transferred to video. As Lucy Lippard describes in *Out of Bounds*:

> Like the flames… the singing sounds are both beautiful and scary, nourishing (lullabies) and fearful (spells or dirges)… As the video's sounds evoke emotions, and the dancing ideograms of the flames evoke images, viewers are still forced to make their own pictures, create their own fantasies or content, since the subject matter remains 'out of sight'. Neither the Rembrandt painting not the news headlines, and certainly not the faces of the aliens and the dreadful messages they convey are ever seen…The layers of **Belshazzar's Feast** peel away from form (handsomely seductive, titillatingly disjunctive) to subject matter (home, holocaust, the media) and finally to content – what emerges and recedes from the 'faults' in the other two.

When the piece was first shown as an installation in 1984, and 1985, Hiller created a deliberately provisional domestic 'interior', including wallpaper, a television set substituting for a fireplace, and several automatic writings scattered informally on the wall. For subsequent installations, she altered the environment to suit each venue, always maintaining the integrity of the video program as the key focus of the work. In her exhibition at California State University Gallery in Long Beach, Hiller designed a 'modern' living room, complete with high-tech furniture and a simulated big screen TV. At the ICA, London and the Museum of Modern Art, Oxford, Hiller created the 'campfire version', situating a number of small red TV monitors on the floor. The 'bonfire version', with its life-size images projected directly on the wall, was

27. Belshazzar's Feast

(1983–84)

PUBLICATIONS:

Brett, Guy, 'Susan Hiller's Shadowland', *Art in America*, April 1991, pp.136–143, 187

Brett, Guy, Parker, Rozsika, Roberts, John, *Susan Hiller 1973-1983: The Muse My Sister*, Derry, London, Glasgow, 1984

Fisher, Jean, *Susan Hiller: The Revenants of Time*, London, Sheffield, Glasgow, 1990, illus.

Lacey, Catherine, Hiller, Susan, *Susan Hiller: Belshazzar's Feast*, London, 1985, illus.

Lippard, Lucy, Hiller, Susan, *Susan Hiller: Out of Bounds*, London, 1986

Nairne, Sandy, *State of the Art: Ideas and Images in the 1980s*, London, 1987

Renton, Andrew, 'In Conversation with Susan Hiller', in Searle, Adrian (ed.), *Talking Art*, ICA Documents 12, London, 1993, pp.85–99

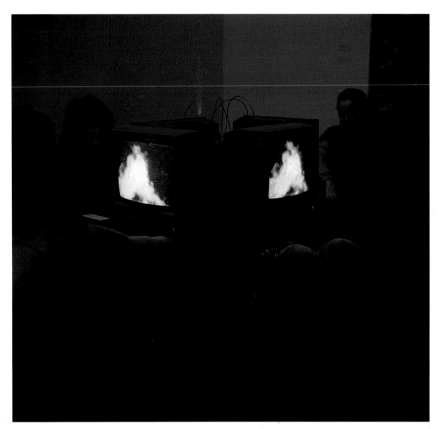

Belshazzar's Feast (1983–84), campfire version, ICA

developed for Kettles Yard, Cambridge and La Ferme du Buisson, Noisiel, and like the Long Beach version, incorporates **The Secrets of Sunset Beach** as the automatic writing works instead of the original portraits.

In 1986, **Belshazzar's Feast** was broadcast all over Britain by Channel 4. In an appropriate recreation of the original events mentioned in the text (the sighting of aliens on TV after station closedown), the programme went out late in the evening. Similarly, for the *State of the Art* series broadcast on Channel 4 and WNET, **Belshazzar's Feast** was shown as a simulated live transmission seen on a television set in a cosy living room.

Like the writing that appeared on Belshazzar's wall, Hiller began to project her writings onto various surfaces. She describes the approach for her *Home Truths* series of wallpaper paintings in her 'State of the Art' interview:

> I do a series of automatic drawings which I then make into slides. The photographic process is important in this work. I project onto the wallpaper surfaces and then I paint, as it were, the background. I'm painting out, I'm not making any marks at all. The marks, the so-called marks are in the negative, they're not there at all, they're spaces and that has to do with a series of puns around writing in the negative and making the invisible visible, which are themes that run through all my work.

Belshazzar's Feast (1983–84), living room version, University Art Museum, Long Beach

29. The Secrets of Sunset Beach
(1987-88)

PUBLICATIONS:
Brett, Guy, 'Susan Hiller's Shadowland', *Art in
 America* , April 1991, pp.136–143, 187
Butler, Susan, 'Dream Documents: Photographs
 by Susan Hiller', *WASL Journal* 29, July 1989,
 pp.26–27
Fisher, Jean, *Susan Hiller: The Revenants of Time*,
 London, Sheffield, Glasgow, 1990

Soon after, Hiller began to project her writing on the environment. At the ICA in London, she created a skirting board for the gallery with a strip of inscribed and painted wallpaper and also projected her writings directly on the floor. This was soon followed by a work completed in 1988 while Hiller was Distinguished Visitor Professor at California State University at Long Beach. She lived in a small beach cottage decorated with a sea motif that she describes as 'a private fantasy world of interior design'. As the University's studio facility was under renovation, Hiller transformed her new residence into her canvas. **The Secrets of Sunset Beach** is a series of ten colour photographs of Hiller's automatic writings projected onto the interior of the cottage. Varying the angles and composition, Hiller created both static still lives and captured moments. In 'Dream Documents: Photographs by Susan Hiller', Susan Butler elaborates:

> The **Secrets of Sunset Beach** …relocates what might be a rational, observable and stable reality within the context of a changing atmosphere. The knowability of the world in any simple terms is questioned, as photography is used here not to fix identifications and clarify outlines, but to suggest how things might be seen in a different light. Or rather, this use of photography recovers from within the very banality of that metaphor the recognition that light itself is always changing, re-drawn, rewriting the environments, the atmospheres we assume to be fixed.

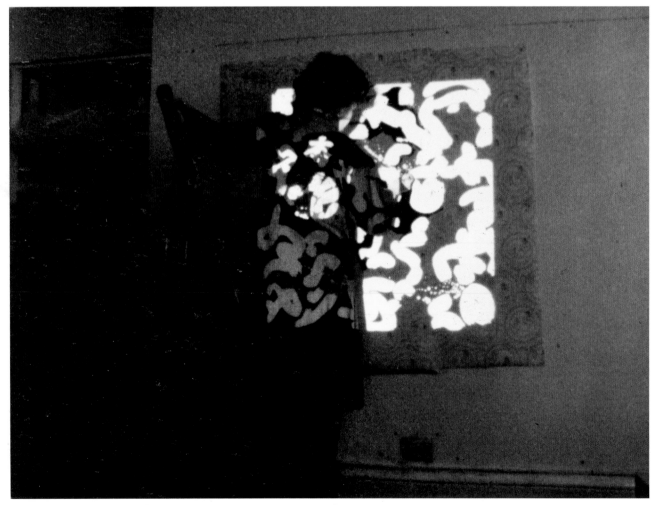

Still from *State of the Art*, the artist painting from a projection.

28. Magic Lantern
(1987)

PUBLICATIONS:

Gary, Indiana, 'Wave Theory', *The Village Voice*, 12 April 1987, pp.103–4

Hiller, Susan, *Magic Lantern*, London, 1987

Brett, Guy, 'Susan Hiller's Shadowland', *Art in America*, April 1991, pp.136–143, 187

Fisher, Jean, *Susan Hiller: The Revenants of Time*, London, Sheffield, Glasgow, 1990

Potts, Alex, 'Susan Hiller's Magic Lantern', *Burlington Magazine*, 1989

Princenthal, Nancy, 'Susan Hiller at Pat Hearn', *Art in America*, January 1989

28. *Magic Lantern* (1987)

Hiller's use of projection became quite literal when, in 1986, she was commissioned by the Whitechapel Art Gallery to create **Magic Lantern** for a series presented in their recently-completed audio-visual space. The audio component of this tape-slide work uses a series of experimental sound recordings of 'ghost' voices, which Hiller had previously used in her closely-related work *Elan* (1982). As in **Belshazzar's Feast**, Hiller combined these with her own improvised vocalisations. Electronic pulses recorded on the soundtrack trigger the visual presentation, consisting of an apparently simple display of red, blue, or yellow discs of projected light. The brochure for the work's initial showing explains:

> Rather than using the tape/slide format in a documentary or lecture format, Susan Hiller has used the medium to evoke the unknown history of the mundane slide projector, referring to its dual origins as a scientific instrument and as a machine for producing specific pleasures by providing experiences of 'pure' light and intense colour.

> The soundtrack of **Magic Lantern** takes as its starting point the 'voices of the dead' experiments of Latvian scientist Konstantin Raudive, who, in the years between 1965 and 1974 claimed he had produced evidence of thousands of human voices on tapes that had been allowed to record the 'silence' of empty rooms. On the soundtrack of Susan Hiller's new work, these 'voices' alternate with the artist's voice singing or chanting, suggesting a pre-conscious or ancient form of language, perhaps fragments of a pattern for which we no longer remember the rules.

> In the same way as the colours projected in **Magic Lantern** produce after-images on the retina which are not 'there' in any external sense, the scratchy noises of the Raudive tapes yield words and phrases to the ear of a committed listener. As always, the ghost in the machine is, paradoxically, the human presence. The artist's voice weaves together projections, interpretations and illustrations, offering us an invitation to search for traces of coherence and order.

Hiller's vocal improvisations first emerge as a solo, then a duet, and culminate in three overlays of her voice. These sections alternate with excerpts from the Raudive material. Simultaneously, three circles of coloured light (red, yellow and blue) grow in size, projecting their pure, singular colour and, when overlapping, creating new shapes and colours. The weaving of the continuously metamorphasizing patterns of intense colour generate random patterns of subjectively-perceived after images: no two moments are the same. Alex Potts describes the experience of viewing this work in an article in the *Burlington Review* in 1988:

> It is by way of the visual spectacle, and its echoing of the formalities of scientific method paraded in the voice experiments, that the conventional separation between the 'rigours' of scientific method and anarchic phantasy are most vividly subverted and blured... The... ambiguities of attending closely to a repeated sensory stimulus are reinforced by the visual spectacle in such a way that distinctions between objective perceptionand subjective response become ever more unstable... Here a clarity and simplicity of form normally associated with the logical certainties of science have become the occasion for dissolving 'rational' definitions of meaning in a deft and seductive display of words and coloured lights... **Magic Lantern** effects a carefully orchestrated and at the same time subversively anarchic interplay of language, sound and spectacle in which you both think you know clearly where you are and forever lose your bearings.

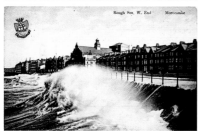

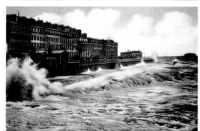

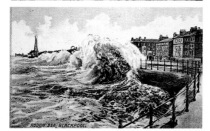

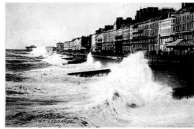

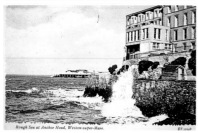

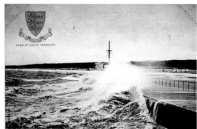

3. *Dedicated to the Unknown Artists*
(1972–76), details

4. MEMORIALS

Dedicated to the Unknown Artists

Monument

Sentimental Representations I, II

Night Light

Child's Play I, II, III

Human Relations I, II, III

Nine Songs for Europe

At the Freud Museum

Throughout her career, Hiller has created pieces as 'memorials' or 'remembrances' to forgotten elements of popular (rather than official or high) culture. In this series of works, she often assumes the role of curator, looking comparatively at objects and artefacts, excavating a cultural history to bring forth what many overlook. As Lucy Lippard points out in *Out of Bounds*:

> Hiller brought with her from anthropology a methodology rather than any specific theory. When she uses cultural artefacts, from potshards to postcards, she does not project meanings onto them but retains their 'idiosyncratic nature' which affects the way they are perceived and illuminates their significance in relation to our own culture – something most anthropologists ignore and of which most artists are ignorant. 'Without being sentimental', [Hiller] remarked 'I think it's a kind of cherishing of things as they are, rather than trying to make them into other things. I deal with fragments of everyday life and I'm suggesting a fragmentary view is all we've got.'

In the same way Hiller was attracted to the fragmentary 'facts' in **Enquiries/Inquiries**, in **Dedicated to the Unknown Artists** she presents more than three hundred picture postcards from English seaside resorts. This collection, begun in 1972, was based on her discovery of a wide variety of images all carrying the same romantic, descriptive title, 'Rough Sea'.

Hiller conducted a detailed analysis and systematic classification of the cards, which are presented against the background of the compiled data. The scientific rigor of her 'methodical methodology' stands in marked contrast to the turbulence of the images. The artist elicits hidden meanings by discreet intervention, which leaves the materials intact but altered by the mode of presentation. In 1977 Hiller explained:

> **Dedicated to the Unknown Artists** was designed as an exhibition piece with myself in the role of curator, collaborating with/extending the work of the unknown artists who created the Rough Sea 'set' of postcards. The 'coincidental' pairings of alternative descriptive languages – verbal and visual- are sustained as levels of presentation throughout the piece. While the charts may look like models of objectivity and the visual images like expressions of subjective internationalisations, they lead to a series of paradoxes involving the unexpressed but intended vs. the expressed but unintended.

3. Dedicated to the Unknown Artists

(1972–76)

PUBLICATIONS:

Brett, Guy, Parker, Roszika, Roberts, John,
Susan Hiller 1973–1983: The Muse My Sister,
Derry, London, Glasgow, 1984

Brett, Guy, 'Susan Hiller's Shadowland', *Art in
America*, April 1991, pp. 136 – 143, 187

Cork, Richard, 'Storm in a Postcard', *The
Evening Standard*, London 17 March 1977,
p.33

Elliott, David, Faure Walker, Caryn, Hiller,
Susan, *Susan Hiller: Recent Works*, Oxford and
Cambridge, 1978

Gooding, Mel, 'McKeever/Hiller', *Art Monthly*,
Dec/Jan 1987, p.86

Hearteny, Eleanor, 'Susan Hiller: Pat Hearn',
ArtNews, Summer 1988, p.193

Hiller, Susan and Kelly, Mary, 'Women's
Practice in Art', in *Ideology and Consciousness*,
Audio Arts Magazine 3, 1977,
audiocasette

Indiana, Gary, 'Wave Theory', *The Village Voice*,
New York, 12 April 1988, pp. 103–4

Olalquiaga, Celeste, *Megalopolis: Contemporary
Cultural Sensibilities*, Minneapolis, 1992, pp.
71–2

Richard Cork wrote the following in *The Evening Standard* on the occasion of the original London showing of **Dedicated to the Unknown Artists**:

> … In the end, however many orgiastic climaxes are celebrated in pictures which range in their art references from Turner and Monet to Pollock's skeins or Morris Lewis' hanging veils, there remains an unavoidable sense of frustration and futility. Waves smashing against the imperialist bulk of the Victorian hotels standing there. And similar holocausts of water, white against the brooding darkness of Blackpool tower, can be interpreted with some confidence as a dramatisation of sexual struggle in its most elemental form.
>
> Even so, none of the postcards proposes the possibility of destruction or even slight damage to the man-made monuments. The hotels stay firm, the tower retains its phallic dominance.

Hiller completed the work during a residency at the University of Sussex and first exhibited the full installation at the Gardner Centre for the Arts. After the first exhibition of **Dedicated to the Unknown Artists**, Hiller began to create *Addenda* to the work, made with the postcards she continues to collect. Each of the ongoing *Addenda* consists of roughly ten numbered and titled sub-sections comprised of varying numbers of postcards and small charts mounted on boards.

In a later work, *Monument*, Hiller continued her cultural investigation. As Mel Gooding explained in 1987, there are strong links between this work and her earlier pieces, including *Dedicated to the Unknown Artists*, and her works that deal with automatism,

> … Those things which her work sets out to reclaim, to bring to light, may take many forms and be from sources both personal and cultural; indeed, that is a distinction that her work dissolves, presenting as it does individual productions that are the outcome of automatic experiment in which personal authorship is regarded as virtually irrelevant… and collections of materials whose authorship is unknown. Yet they achieve a sort of collective utterance, the burden of which would be unforseen by any of those who have contributed unconsciously and unselfconsciously to their making.

In November 1980, while walking through a London park, Hiller noticed a series of ceramic plaques set into a wall. Each commemorated a Londoner who had died in the act of saving or attempting to save the lives of others. Attracted to this landmark by her interest in collections and cultural artefacts, Hiller returned the following day to photograph forty-one of the titles (her age at the time). As she described in *The City as Art*, a talk published by the AICA, Belfast, her simple presence at the site drew attention to the something that had always been there:

> When I returned..there were people sitting on park benches in front of them eating their lunches, who turned round over their shoulders to look, as if for the first time, at what I was photographing. And when they had seen the plaques they said things like 'Oh! Isn't it sad? Isn't it dreadful?' But what struck me was that they had sat in front of these perfectly visible objects for years and years, and the objects had been, literally, invisible.

For **Monument** Hiller assembled her photographs in a diamond-shaped cross pattern with a park bench facing away from the plaques. On the seat she placed a set of headphones which plays a soundtrack she wrote and recorded, musing on thoughts raised by the plaques – death, heroism and representation. Together, as Tony Godfrey commented in *Artscribe*, the audio and visual elements create a powerful installation:

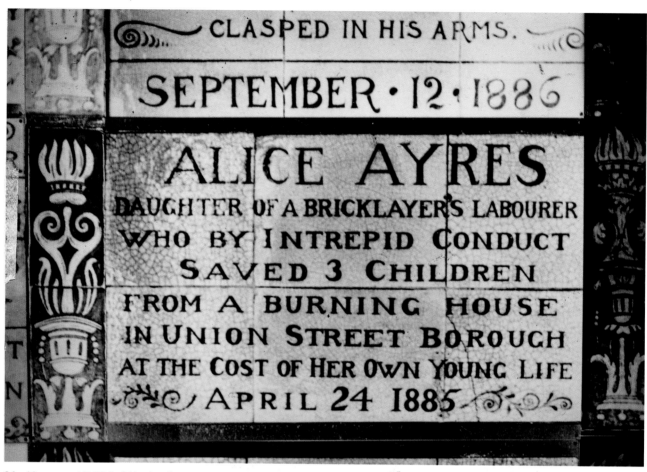

CLASPED IN HIS ARMS.

SEPTEMBER · 12 · 1886

ALICE AYRES
DAUGHTER OF A BRICKLAYER'S LABOURER
WHO BY INTREPID CONDUCT
SAVED 3 CHILDREN
FROM A BURNING HOUSE
IN UNION STREET BOROUGH
AT THE COST OF HER OWN YOUNG LIFE
APRIL 24 1885

21. *Monument* (1980–81), detail

Death belongs in our society to the darkness of night, to the repressions of sleep, and dream. Hiller's tape partakes of the language of dream, where the identity of the speaker is inconstant, lost and retrieved… There is not one voice but many.

This is an extremely theatrical installation, though it remains at all times restrained, low-key even. The installation itself with its pale blue and brown tablets and its economy of placements is very beautiful… The connection between the mute, sombre images and the elusive, allusive wanderings of the text is fascinating in its provocations: the atmosphere of the piece and the ruminations it engenders stay in one's head for a long while.

This pivotal piece foreshadowed Hiller's increasing interest in death and was also reminiscent of early investigations which used the viewer as a participant in the work. Hiller explains, 'In **Monument** where..the entire piece is activated by a person who sits on a bench listening to a sound tape, a person must be prepared to be seen in public performing a private act of listening. Since this person is seen by other viewers against a backdrop of photographic images, the piece exists as a tableau with a living centre, while the person is also the audience for the work.'

Hiller made three versions of **Monument**, with various accompanying studies. The original, included in this exhibition, consists of forty one photographs, each 508 × 762mm and is subtitled *British Version*. A second *Colonial Version* is in the collection of the Leeds City Art Gallery and was designed for exhibition in Australia, Canada, the United States and other former British colonies. It was created with second

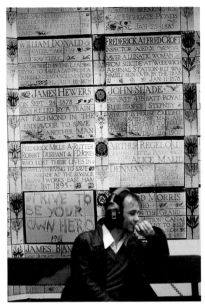

21. *Monument*, British version,
Ikon Gallery

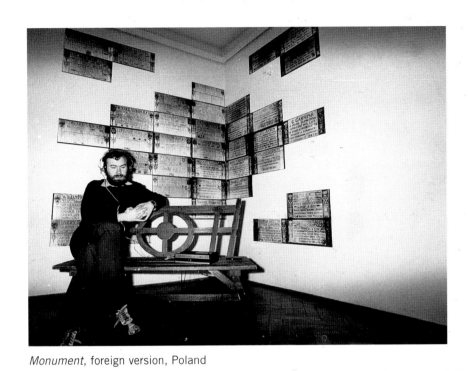

Monument, foreign version, Poland

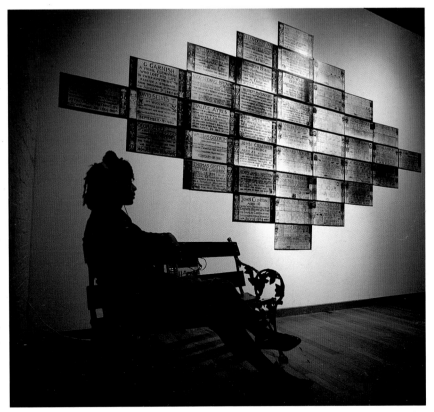

Monument, Colonial version,
ICA, London

21. Monument

(British version) (1980 – 81)

EXHIBITIONS:

1981 Ikon Gallery, Birmingham
Rochdale Art Gallery, England

1984 *Susan Hiller: New Work*, Orchard Gallery,
Derry; Gimpel Fils, London; Third Eye
Centre, Glasgow

1986 *Susan Hiller: Out of Bounds*, ICA, London
Force of Circumstance, PPOW Gallery, New
York

1990 *New Urban Landscape*, World Financial
Centre, New York

PUBLICATIONS:

Brett, Guy, Parker, Roszika, Roberts, John,
Susan Hiller: The Muse My Sister, Derry,
London, Glasgow, 1984

Fisher, Jean, *Susan Hiller: The Revenants of Time*,
London, Sheffield, Glasgow, 1990

Godfrey, Tony, 'Susan Hiller at Arnolfini',
Artscribe 31, October 1981, p.58

Gooding, Mel, 'McKeever/Hiller', *Art Monthly*,
Dec/Jan 1987, p.86

Guest, Tim, Hiller, Susan, *Susan Hiller:
Monument*, Birmingham, Toronto, 1981

Hiller, Susan, 'Monument', in Kelly, Liam (ed.),
The City as Art, Belfast, 1994, pp.22 – 31

Lippard, Lucy, Hiller, Susan, *Susan Hiller: Out of
Bounds*, London, 1986

generation images, each 254 × 508mm. The last, *Foreign Version*, has slightly smaller, third generation photographs with audio tapes translated for exhibition in countries where English is not a major language.

In 1980/81, Hiller created two works that form an interesting comparison with **Monument**. Although they use 'real' materials rather than photographs, they present the same themes of death, gender and representation, in a similar, grid-like structure. The pieces were inspired by the recent deaths of the artist's two grandmothers, both named Rose: **Sentimental Representations in Memory of My Grandmothers (Part I for Rose Ehrich, Part II for Rose Hiller)**. They are composed of small panels or pages of rose petals suspended in acrylic medium which, when seen from a distance, appear as delicate chromatic studies of light and hue, reminiscent of Hiller's earlier sewn canvases. Interspersed throughout each work are the artist's musings on memory, language and death. As in **Monument**, the number of panels is important: the total represents the age of each of her grandmothers at their death. As Jean Fisher noted in *The Revenants of Time*:

> Institutional forms of representation that aim to impose a homogenous history and subjectivity have little to do with memory as lived experience, as that which provides the self with its sense of connectedness to the processes of life. It is the latter concern that unites **Monument** with **Sentimental Representations**. These works appeal to memory itself, and its capacity to contract time through unconscious leaps into the multiple layers of the past.

Death, time and memory are also inherent themes in a large video installation Hiller finished in 1991, commissioned by Matt's Gallery in London, the Mappin Gallery in Sheffield and the Third Eye Centre in Glasgow. Much like the postcards in **Dedicated to the Unknown Artists**, *An Entertainment* focuses on a collection of

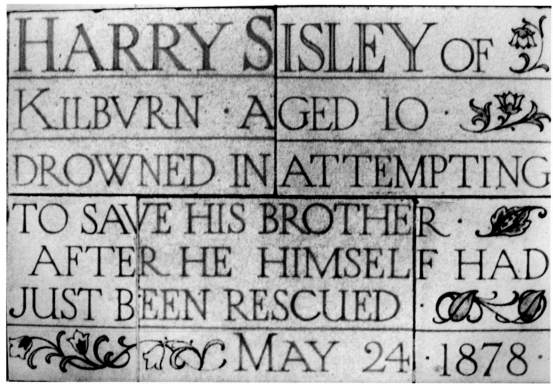

21. *Monument* (1980–81), detail

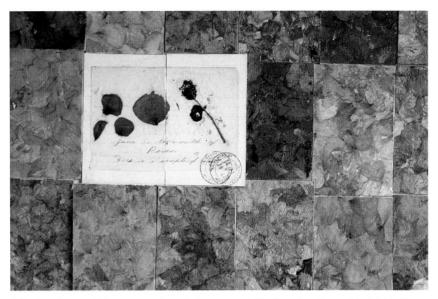

22. Sentimental Representations in Memory of My Grandmothers (Part I for Rose Ehrich) (1980–81), (detail)

22, 23. Sentimental Representations in Memory of my Grandmothers (Part I for Rose Ehrich) (Part II for Rose Hiller)

(1980–81)

Note: Part II was damaged in 1982 and subsequently restored by the artist. The canvas was restretched and the original dimensions were slightly altered. Both pieces were then placed in perspex boxes for safety.

EXHIBITIONS:

1981 *A Mansion of Many Chambers: Beauty and Other Works*, Cartwright Hall, Bradford; Art Gallery, Oldham;
Gardner Centre, Brighton; The Minories, Colchester; Mappin Art Gallery, Sheffield; City Art Gallery, Worcester;
Glynn Vivian Art Gallery, Swansea; The Art Gallery, Southampton (Part I only)
New Works, Graeme Murray/Fruitmarket Art Gallery, Edinburgh (Part I only)

1982 *Sense and Sensibility in Feminist Art Practice*, Midland Group Gallery, Nottingham
Susan Hiller, Gimpel Fils Gallery, London (Part II only)

1984 *Susan Hiller: Ten Years Work*, Third Eye Centre, Glasgow

1990 *Susan Hiller: The Revenants of Time*, Matt's Gallery, London; Mappin Gallery, Sheffield; Third Eye Centre, Glasgow, illus.

1991 Gimpel Fils Gallery, London

PUBLICATIONS:

Brett, Guy, Parker, Roszika, Roberts, John, *Susan Hiller 1973–1983: The Muse My Sister*, Derry, London, Glasgow, 1984

Brett, Guy, 'Susan Hiller', *Art in America*, January 1996

Brown, David, Hiller, Susan, *A Mansion of Many Chambers: Beauty and Other Works*, London, 1981

Fisher, Jean, *Susan Hiller: The Revenants of Time*, London, Sheffield, Glasgow, 1990, illus.

Tickner, Lisa, *Sense and Sensibility in Feminist Art Practice*, Nottingham, 1982

segments from Punch and Judy puppet shows. Hiller filmed over several years in various locations around England. Richard Shone describes the installation in the October 1995 issue of *Art Forum*:

> Susan Hiller's installation *An Entertainment*, 1990 – four video projectors and sound in a square room – is 26 minutes long, during which huge coloured images … are thrown against the wall; the soundtrack evokes a seaside audience as well as the murderous doings of Mr Punch with his thrusting nose; entertainment clichés ('Oh yes he is!' 'Oh no he isn't!') are menacingly intoned. Memories of Edvard Munch and James Ensor … and the cruel caricatures of Regency London all spring to mind in Hiller's absorbing disquition on ritual and myth, vicious comedy, violence and death. The brutality of what passes for entertainment still erupts in London life, and Hiller has unnervingly traced one of its histories.

Unfortunately, due to the scale and complexity of *An Entertainment*, access to the piece has been limited, as it was in Hiller's early performance works. As a result, the artist's next series of works were designed with flexibility in mind. As Guy Brett points out in *Art in America*:

> If *An Entertainment* exemplified the projection of light on a scale which envelops and destabliizes the spectator, **Night Light** embodied a kind of 'anti-projection', a contraction of light and an intimate scale. It was an ironic reversal beautifully calculated as a fresh means of insight.

31. Night Light
(1991)

32, 34, 35. Child's Play I , II, III
(1991–92)

30, 36, 37. Human Relations I, II, III
(1991–92)

32, 34, 35. *Child's Play I, II, III*
1991–92 (details)

Night Light is part of a series of 'light sticks', composed of sequences of slides illuminated by miniature night lights mounted on a multiple-socket power strip. **Night Light** and **Illuminations** re-interpret images Hiller used in *An Entertainment*. **Child's Play** is based in a children's card game originating in Mexico and popular throughout the United States. **Human Relations** features skulls which have been important in the development of evolutionary theory. Hiller wrote the following to accompany the first showing of *Human Relations*:

> We display some bones of the dead in museums and universities, but these mortal remains no longer remind us of our common end. While once a single skull spoke fluently of the death of everyone, today such relics are silent, or relegated to other discourses.

> Previous generations made painting and sculpture to keep the fact of mortality in view; our collections of bones focus our sight on other issues. But we will fear the dark, death, and the unknown – and ward of four fear in traditional ways.

> For instance, bedroom night lights, very contemporary in design, always have candle-shaped bulbs, formally archaic, which evoke (by referring to a resonant and distant past when candles were in common use) fantasies of childhood or of the historical past of our collective long-agos.

Shortly after Hiller completed her first set of 'Light Sticks', she began another illuminated work, **Nine Songs from Europe**. The work is based on nine postcards Hiller purchased in 1989 on a visit to Vienna. Like **Dedicated to the Unknown Artists**, the cards share a similar theme – each depicts the same image of the last Hapsburg Emperor accompanied by a verse from the imperial anthem which begins 'God save the Emperor and his family…'. Each, however, is printed in a different language.

The nine postcards are part of a set of thirteen souvenir cards accommodating all of the national groups that were once part of the vast domain of the Austro-Hungarian Empire. Hiller was able to collect examples in Ukranian, Staroslovo (old Slavic), Czech, Polish, Hebrew, Croatian, Slovenian, Romanian and Italian. (The missing cards were presumably in Hungarian, Slovak, Serbian and Macedonian.)

EXHIBITIONS
1991 Thomas Solomon's Garage, Los Angeles
(*Night Light , Child's Play I, Human Relations I*)
1992 Pat Hearn Gallery, New York (*Night Light* and *Child's Play I*)
Anderson O'Day, London (*Human Relations*)
1995 Gimpel Fils Gallery, London

PUBLICATIONS
Brett, Guy, 'Susan Hiller', *Art in America*,
Kent, Sarah, 'Susan Hiller: Gimpel Fils', *Time Out*, 5–2 July 1995, p.54

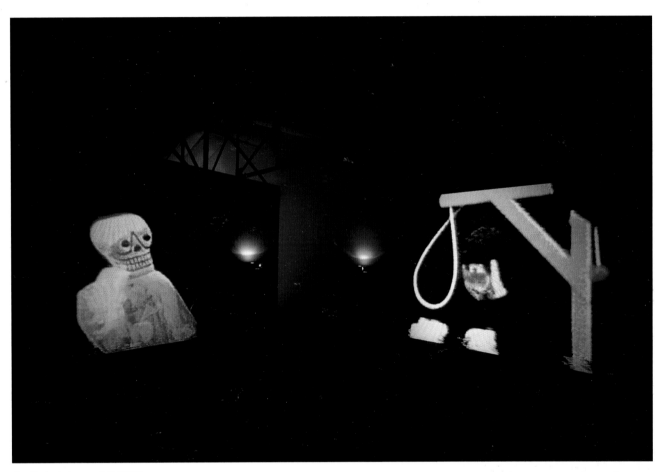

An Entertainment (1991)

33. *Nine Songs from Europe* (1991–95), detail

33. Nine Songs from Europe

(1991–95)

Not previously exhibited or published.

Nine Songs from Europe illuminates and commemorates certain histories which originated in the collapse of the imperial power which, prior to World War I, united and divided diverse ethnic groups in central Europe. Hiller has made frames of rubber, glass and metal bolts for the postcards which are placed in front of German inspection lamps, to illuminate the images from behind. The postcards have been treated with uneven layers of varnish which create a vellum-like transparency that implies that we can now 'see through' something which was once opaque. The artist herself describes the effect as:

> disturbing, and at the same time rather attractive. A mellow antique light is given off by each 'song'; uneven layers of varnish seem to produce the shapes of maps or territories. All the materials I chose were very ordinary and used a low-tech, rather provisional way that is actually quite modern and very efficient. Yet the work displays a distinct menace.

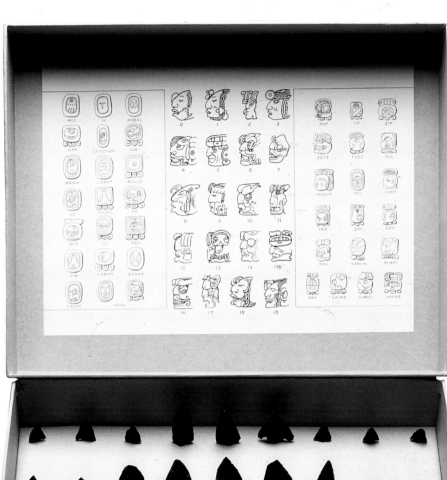

38. *At the Freud Museum* (1992–), detail, *CHAMIN-HA'/house of knives*

38. At The Freud Museum

(1992–)

Vitrine I: .001 – NAMA-MA/mother, .002 – Ευχη/prayer; .003 – PANACEA/cure; .004 – SLAPSTICK/slaep' stk; .005 – VIRGULA DIVINA/water-witching;.006 – CHAMIN-HA'/House of Knives; .007 – KOMOIΔIA/comedy; .008 – COWGIRL/kou' gurl; .009 – FÜRHER/guide; .010 – A' SHIWI/native; .011 – EAUX-DE-VIE/spirits; .012 – FATLAD/fat lad; .013 – INITIATION/beginning; .014 – MOROR/bitter; .015 – AΔHΣ/Hades; .016 – PAINJENISUL SATANIE/Satan's cobweb; .017 – LA PESTE/plague; .018 – PLIGHT/plite; .019 – SOPHIA/wisdom; .020 – HEIMLICH/homely; .021 – (SIMCHAS)/joy; .022 – SEANCE/seminar

Vitrine II: .023 – PROVENANCE/source; .024 – REX/king; .025 – OCCULT/hidden; .026 – LUNES/moons; .027 – RELEQUIA/relic; .028 – INTERIOR/in teer' I or; .029 – LANGUES/tongues; .030 – HERMANOS/brothers; .031 – SEQUAH/prairie flower; .032 – SOUVENIR/reminder; .033 – VISION/viz'h'n; .034 – JOURNEY/jIr'ni; .035 – (BARAKA)/power; .036 – RANK/rÂnq; .037 – AMUSE/,muz; .038 – MAQUETTE/model; .039 – DEORA DE/God's tears; .040 – MAR ALTA/rough sea; .041 – REGENERATE/born again; .042 – EXTRA/beyond; .043 – ILLUMINATION/enlightenment; .044 – MENAGERIE/ animal house

Versions of nos. 11 and 27 published in limited editions of 10 each

EXHIBITIONS:

1994 *Susan Hiller*, The Freud Museum, London (nos. 1–23)

World in a Box, Whitechapel Art Gallery London (Chamin-ha', Nama-ma, Sophia)

1995 *Susan Hiller*, Gimpel Fils Gallery, London (nos. 24–34)

PUBLICATIONS:

Brett, Guy, 'That Inner Vision Thing at Freud's', *The Guardian*, 6 April 1994, p.29

Bush, Kate, 'Susan Hiller: Freud Museum', *Untitled: A Review of Contemporary Art* 5, Summer 1994, p.12

Clifford, James, 'Inmigrant' *Sulfur*, 37 (Autumn) 1995, p.32–52

Hiller, Susan, *After the Freud Museum*, London, 1995 (illus. nos.1–12, 14–27, 34)

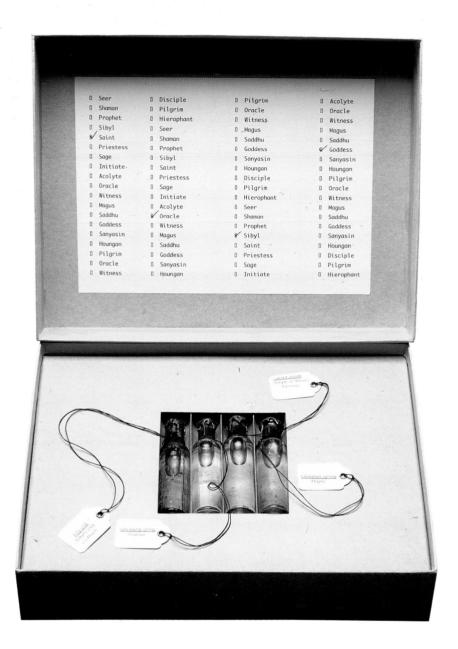

38. *At the Freud Museum* (1992–), detail, *SOPHIA/wisdom*

39. *Bright Shadow* (1994)

Next page:
38. *At the Freud Museum* (1992–),
detail

Hiller continues to use ordinary materials to evoke moments of cultural, historical and personal disturbance. In 1992 she was invited by Book Works and the Freud Museum to create a work for exhibition in Sigmund Freud's last home, which has been turned into a museum. Attracted by the rich artefactual nature of this historical museum, in 1994 she installed a series of small boxes to be presented open, as elements in a vitrine. **At the Freud Museum** is an on-going project which combines objects and representations which may be pictorial, digrammatical or literary. As Hiller wrote in the book which followed, titled *After the Freud Museum*, 'My starting points were artless, worthless artefacts and materials – rubbish, discards, fragments, trivia and reproductions – which seemed to carry an aura of memory and to hint at meaning something, something that made me want to work with them and on them.'

Each combination of elements is boxed, labelled (often in an exotic or ancient language and translated into English) and categorised. As Kate Bush writes in *Untitled: A Review of Contemporary Art* in 1994: 'Hiller's collection, with its functional specimen boxes and its array of shards and fragments summons a potent psychoanalytic metaphor: the plumbing of the human mind as an act of archaeology, an excavation of the unconscious where nothing is lost and everything is conceivably waiting to be disinterred.'

Hiller's serious but unsettling technique of juxtaposing knowledge derived from anthropology, psychoanalysis and other scientific disciplines with materials usually considered to be of no great weight is reminiscent of **Dedicated to the Unknown Artists** and also the installation work *Fragments* (1978–80). The Freud Museum project provided the artist with a venue that was particularly appropriate to connect this approach with her interest in dreams. In her seminar published as 'Working through Objects' in the book *Thinking About Art*, Hiller says:

> Each box I've made and positioned in the vitrine seems to me to be part of a process which is actually very dreamlike. I'm again using the notion of dream in several senses. If you think of Freud 's notion of the dream as a narrative that had both a manifest and a hidden content, this might have something to do with the relationship between the story told by the storyteller and the story that was being heard. I tried to make my boxes exemplify that kind of approach, so that they present the viewer with a word (each is titled), a thing or object, and an image or text or chart, a representation. And the three aspects hang together (or not) in some kind of very close relationship which might be metaphoric or metonymic or whatever.

When Hiller exhibited this series at the Freud Museum, she simultaneously projected *Bright Shadow*, the video loop within the box **Seance/seminar**, in the darkened front window of a London gallery. The video programme is an endless loop of images Hiller filmed when a dark shuttered room accidentally functioned as a camera obscura on a bright day. The title **Bright Shadow** is a deliberate oxymoron. In *At the Freud Museum*, the video is shown on a tiny lcd monitor, accompanied by an image from Athanius Kircher's 1671 treatise on the principles of the camera obscura and magic lantern. In the present exhibition Hiller has also projected it directly onto the floor, much as she did with the automatic writings cast on the walls and floor during her exhibition at the ICA in London in 1986. In 'Working through Objects' the artist says:

> I thought of the piece as a collection of shadows, like other collections I've made... And of course I like the idea of the camera obscura, the dark room, the box. The title of my box [Seance/seminar] plays with the supposed contradiction between rationality-irrationality; in French the word seance just means 'seminar'.

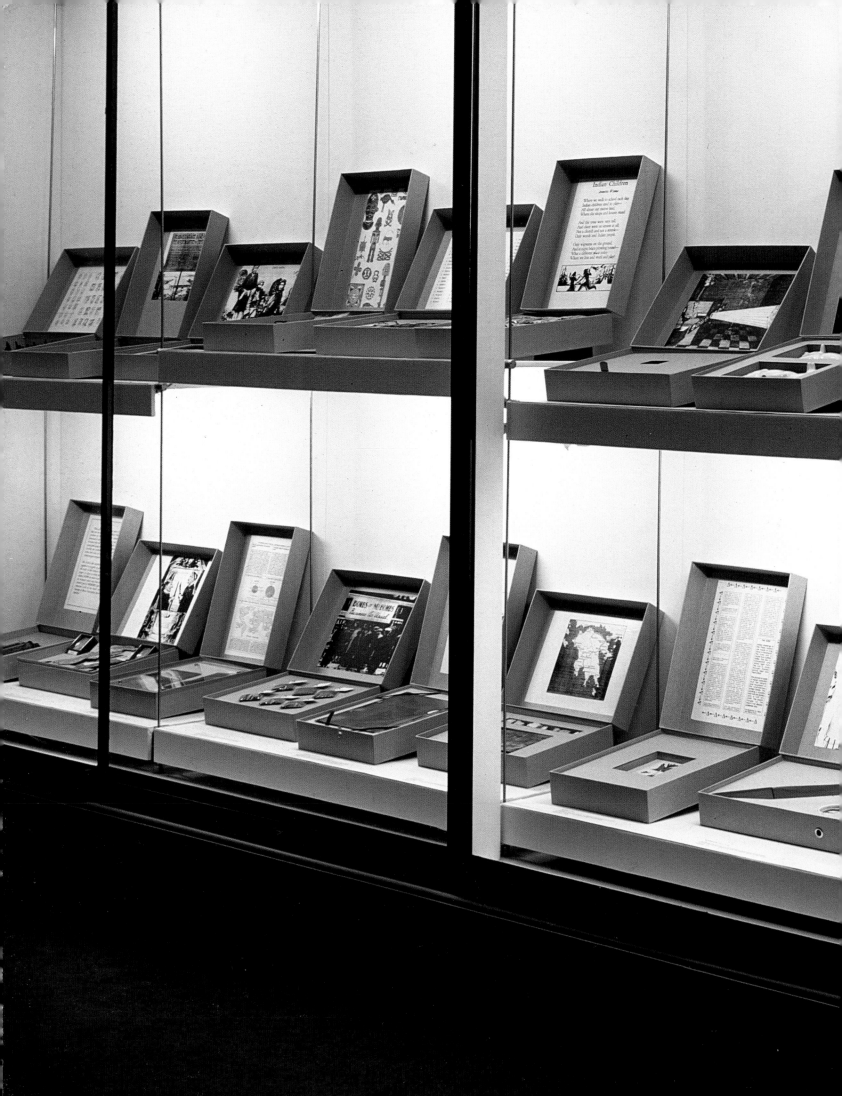

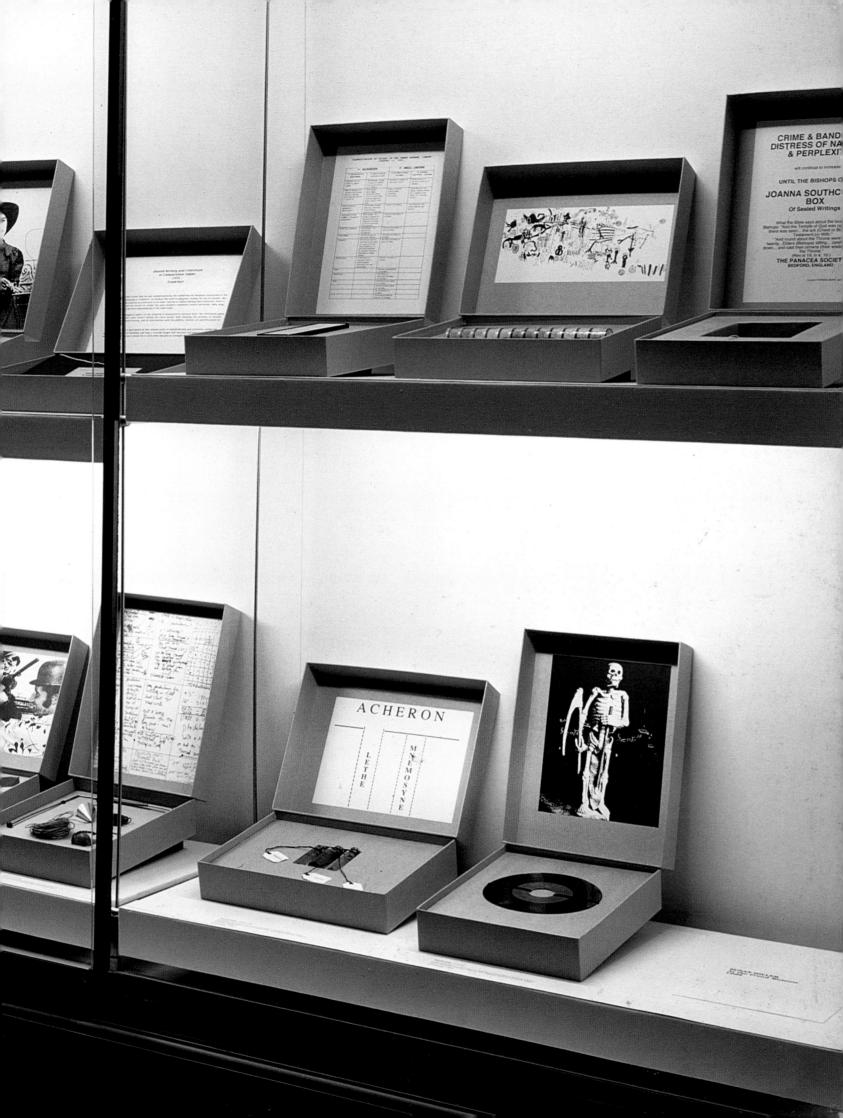

List of Works

All works are as configured for exhibition at Tate
Gallery Liverpool, and are in the collection of
the artist unless otherwise stated. Dimensions
are in millimetres, height × width × depth.

1. Hand Grenades
1969–72
12 glass jars, rubber stoppers, ashes of paintings,
pyrex bowl, labels
110 × 180 × 180
illustrated pp.29, 58

2. Untitled 1968–7? (Painting Block)
197?
oil on canvas cut and bound with thread into
block form
65 × 105 × 105
illustrated p.61

3. Dedicated to the Unknown Artists
1972–76
postcards, charts, and map mounted on boards,
book and notes
14 panels, each 660 × 1048
illustrated pp.12,13,76

4. Sisters of Menon
1972–79
section I: 4 L-shaped panels, blue pencil on A4
paper with typed labels (1972)
section II: 4 panels, typescript and gouache on
paper (1979)
912 × 642; 318 × 230
illlustrated pp.65,66,67

5. Enquiries / Inquiries
1973–75
4 cycles of 80 slides, neon sign
dimensions variable
illustrated pp.54,55,56

6. Big Blue
1973–76
acrylic on canvas bound in covered book, slide
222 × 349 × 64
illustrated p.62

7. 48" × 48" 1974–75 (Painting Block)
1973–80
oil on canvas cut and bound with thread into
block form
40 × 150 × 150
illustrated p.14

8. 43" × 59" 1974–76 (Painting Block)
1973–80
oil on canvas cut and bound with thread into
block form
80 × 155 × 110
illustrated p.14

9. 54" × 36" 1974–77 (Painting Block)
1973–80
oil on canvas cut and bound with thread into
block form
80 × 155 × 75

10. 60" × 51" 1974–80 (Painting Block)
1973–80
oil on canvas cut and bound with thread into
block form
60 × 165 × 130
illustrated p.14

11. 42" × 60" 1974–81 (Painting Block)
oil on canvas cut and bound with thread into
block form
70 × 155 × 110
illustrated p.14

12. 60" × 48" 1974–82 (Painting Block)
1973–82
oil on canvas cut and bound with thread into
block form
85 × 165 × 115

13. 48" × 48" 1974–83 (Painting Block)
1973–83
oil on canvas cut and bound with thread into
block form
105 × 105 × 105

14. 36" × 54" 1974–84 (Painting Block)
1974–84
oil on canvas cut and bound with thread into
block form
75 × 160 × 75

15. Measure by Measure
1973–92
20 burettes, rubber stoppers, ashes of paintings,
4 glass measuring cylinders, lead tags, steel shelf
711 × 1294 × 241
illustrated p.60

16. Dream Mapping
1974
vitrines containing notebooks with dream maps
and documentation, wall drawing
7 vitrines, each 412 × 465 × 219
illustrated pp.36,37,52,53

17. Get William
1975–81
section I: pencil on paper under pink perspex
(1975)
section II: photocopy and water-colour on pink
paper (1981)
653 × 912; 344 × 470
illustrated pp.68,69

18. Mary Essene
1975–81
section I: pencil on paper under blue perspex
(1975)
section II: typescript and water-colour on blue
paper (1981)
649 × 910; 332 × 464
illustrated pp.21,69

19. My Dearest
1975–81
section I: pencil on paper under pink perspex
(1975)
section II: typescript and water-colour on pink
paper (1981)
1070 × 615; 546 × 318
Courtesy Gimpel Fils, London
illustrated pp.21,68

20. So Don't Let it Frighten
1975–81
section I: pencil on paper under blue perspex
(1975)
section II: typescript and water-colour on blue
paper (1981)
640 × 915; 325 × 460
illustrated pp.68,69

21. Monument (British Version)
1980–81
c-type photographs, soundtrack and park bench
41 photographs, each
overall dimensions: 381 × 546
soundtrack running time: 14 minutes 23 seconds
Tate Gallery
Purchased 1994
illustrated pp.30,31,32,78,80

*22. Sentimental Representations in Memory of my
Grandmothers (Part I for Rose Ehrich)*
1980–81
rose petals in acrylic medium, ink on paper,
photocopies
1137 × 810
Arts Council Collection, Hayward Gallery,
London
illustrated pp.48,81

*23. Sentimental Representations in Memory of my
Grandmothers (Part II for Rose Hiller)*
1980–81
section I: rose petals in acrylic medium, ink on
paper, photocopies
section II: photographs
1380 × 1080; 330 × 200
The John Creasey Museum, Salisbury
illustrated p.8

24. Bad Dreams
1981–83
colour photographs, white paint on curtain
12 photographs, each 429 × 625
illustrated p.70,71

25. Lucid Dreams I
1983
drawing ink on colour photographs on board
4 panels 555 × 455
illustrated p.18

26. Lucid Dreams II
1983
drawing ink on colour photographs on board
4 panels 555 × 455
illustrated p.19

27. Belshazzar's Feast
1983–84
video projection
dimensions variable
running time: 19 minutes 11 seconds
Tate Gallery
Purchased 1984
illustrated p.72

28. Magic Lantern
1987
slide projection with soundtrack
dimensions variable
running time: 12 minutes
illustrated pp.40,41,75

29. The Secrets of Sunset Beach
1987
hand printed R-type photographs
10 photographs, each 565 × 465
illustrated pp.24,25

30. Human Relations I
1991
10 slides, brackets on night lights in multiple-
socket power strip
1524 × 64 × 51

31. Night Light
1991
2 × 6 slides, brackets on night lights in multiple-
socket power strip
2 sections each: 915 × 64 × 51

32. Child's Play I
1991
12 slides, brackets on night lights in multiple-
socket power strip
1829 × 64 × 51
illustrated pp.46,47,82

33. Nine Songs from Europe
1991–95
9 postcards, varnish, paper, rubber, glass, 9
inspection lamps, 9 steel tables
dimensions variable
illustrated p.84

34. Child's Play II
1992
10 slides, brackets on night lights in multiple-
socket power strip
1524 × 64 × 51
illustrated pp.46,47,82

35. Child's Play III
1992
10 slides, brackets on night lights in multiple-
socket power strip
1524 × 64 × 51
illustrated pp.46,47,82

36. Human Relations II
1992
10 slides, brackets on night lights in multiple-
socket power strip
1524 × 64 × 51

37. Human Relations III
1992
10 slides, brackets on night lights in multiple-
socket power strip
1524 × 64 × 51

38. At The Freud Museum
1992-
vitrine installation: boxes, artefacts, notes, LCD
monitor and videotape *Bright Shadow*
44 boxes, each 25 × 254 × 64
illustrated pp.6,85,86,87,88,89

39. Bright Shadow
1994
video projection
dimensions variable (looped)
illustrated pp.87, back cover

Biography

Susan Hiller was born in the United States in 1940. She studied for a PhD in anthropology and conducted field research in Central America, until she experienced what she described as a 'kind of crisis of conscience' which led her to turn away from a career as an anthropologist. At the end of the 1960s she moved to Europe and travelled extensively before settling in London, where she had her first solo exhibition in 1973. Susan Hiller lives and works in London.

Selected Bibliography

Selected books and articles appear in the Catalogue section of this publication. The following list includes only a selection of the artist's own publications, and selected exhibition catalogues.

Artist's Publications

Selected texts, books, record sleeves

1973
'Elements of Science Fiction', *Art and Artists* 8, no.7, October, cover, pp.28–35

1974
'Transformation', *Wallpaper* 2, December, London and New York, p.4

1975
'Missing, Believed Dead: a Checklist of Louisiana Indians', *Nola Express*, New Orleans, pp.10–11

1976
(with David Coxhead) *Dreams: Visions of the Night*, London; New York; Paris; Amsterdam; Frankfurt; Tokyo. (Reprinted 1981, revised and reprinted 1989,1991)
Enquiries/Inquiries, broadsheet accompanying exhibition, Serpentine Gallery, London
Notes, Gardner Centre for the Arts, University of Sussex, Brighton, artist's book
Rough Sea, Gardner Centre for the Arts, University of Sussex, Brighton, artist's book

1977
'Sacred Circles: 2,000 Years of North American Indian Art', *Studio International* 193, January, pp.56–58, reprinted 1979 in *Art and Society History Workshop Papers*, London, p.21

1978
'Mugshots: Comments', *Studies Towards a Portrait*, by Paul Buck, Cambridge

1979
'Defining Females', review of *Oxford Women's Anthropology*, edited by Shirley Ardner, *Spare Rib*, March, p.40
Enquiries/Inquiries, Gardner Centre for the Arts, University of Sussex, Brighton, artist's book

'Toward an Archeology of Fragments', *in'hui* 9, Autumn, France, pp.121–127

1980
'Radical Artists' Attitudes Toward the Gallery', *Studio International* 195, Autumn, pp.37–38
'10 Months', *Block* 3, text by Lisa Tickner, London, pp.27–29
'Dream Mapping', *New Wilderness Letter* 10, Winter, New York, pp.82–85

1981
'Monument', *File*, 5, no.2, Fall, Toronto
Monument, A Space, Toronto
'Women's Work', *Circles*, Midland Group Gallery, Nottingham, pp.1–3
'10 months, 12 Years', *About Time*, London

1982
'Saving: A Study in the Visible World', *City Limits* 24 December – 6 January, pp.76–77

1983
Sisters of Menon, London
'Seance Seminar', *Reaktion* 7, Verlaggalerie Leamen, West Germany

1984
'Monument', *Live Art*, February, Adelaide, pp.80–82
'Project', *Art & Text* 13 & 14, Summer/Autumn, Melbourne, pp.100–109

1985
'Susan Hiller', *Eau de Cologne* 1, November, pp.52–54

1986
'Art Pages: Mother Tongue', *Circa* 27, March/April, pp.24–25
'Strong Language', *Student Film and Video Art Prizes*, Arts Council of Great Britain, London

1987
A Town Called Walker, 12" record sleeve
Cry Mercy, Judge, Single and 12" record sleeve
Flashlight, album and cassette cover, Tom Verlaine, Phonogram
'J'accuse', review of *Through Our Eyes: Popular Art and Modern History*, by Guy Brett, Studio International 200, no.1017, June, pp.62–63

1990
'Artist's Page', *Noise* 12, Paris, pp.20–21
'Collective Contingent', review of *The Object of Performance: The American Avant-Garde Since 1970* by Henry M. Sayre, *TLS*, 2–8 February

1991
'Helio Oiticia: Earth Wind and Fire', *Frieze* 7, November/December, pp.26–31

1992
The Myth of Primitivism, London and New York (Reprinted 1992, 1993), compiled and edited by Susan Hiller

1993
'An Artist on Art Education', *The Curriculum for Fine Art in Higher Education*, Wimbledon School of Art/Tate Gallery, London, pp.43–49
'O'Keeffe as I See Her', *Frieze* 11, Summer, pp.26–29

1994
'Monument', *The City as Art*, edited by Liam Kelly, AICA, Belfast, pp.22–31
'An Artist Looks at Art Education', in *The Artist and the Academy*, edited by Nicolas de Ville and Stephen Foster, John Hansard Gallery, University of Southampton

1995
After The Freud Museum, London, 1995
'Remaking Art', *Cahier* 4, October, Witte de Withe, Rotterdam
'The Sisters of Menon 1, 2, 3', *Wordsworth* 2, no.1, Spring, cover, pp.33–43 (Originally accepted for publication in 1982)
'The Word and the Dream', *Random Access: Staking the Claims for Art & Culture*, edited by Dr Nikos Papstergadis and Pavel Buchler, London
'Untitled Comments on Yves Klein', *Yves Klein Now: Sixteen Views*, South Bank Centre, London

1996
Thinking About Art: Conversations with Susan Hiller, edited by Barbara Einzig, preface by Lucy Lippard, Manchester

Selected Audio, Video, Film

1975

'Wallpaper on Cassette: Symmetrical Notes
From the Dream Seminar', *Audio Arts
Magazine Supplement*, audiocassette

1977

With Mary Kelly, 'Women's Practice in Art',
'Ideology and Consciousness', *Audio Arts
Magazine 3*, no.3, audiocassette

1981

Swayne, Chris, *Susan Hiller: A Provisional Portrait*,
Arts Council of Great Britain, London,
16mm colour Wlm, 17 mins

1983

'Some Notes on my Exhibition at Gimpel Fils in
March/April 1983', *The Critics*, BBC Radio

1986

Belshazzar's Feast, Channel 4 Television, 29 January

1987

Interview with the artist in *State of the Art: Ideas
and Images in the 1980s*, produced by Sandy
Nairne in collaboration with GeoV Dunlop
and John Wyver, Channel 4 Television, 25
January

Imaginary Women, produced by Gina Newsom in
collaboration with Marina Warner, Channel
4, Television, 3 July

1988

British Art: The Literate Link, KCRW Radio, 29
February

Elan, 'An Anthology of Audio by Artists', *Tellus*
21, New York

1989

Interview *Wide Angle*, produced by Morton
Films, London, Anglia TV, 23 May

The Late Show, BBC2, London, 16 February

1992

With Joseph Schwartz, *Science and Creativity*,
ICA, London, 2 July, audiocassette

1994

Archer, Michael, 'Interview with Susan Hiller',
Audio Arts Magazine, 4, no.1, audiocassette
(cover illus)

1995

Invisible Damage: Local Customs, audiocassette,
Catalyst Arts, Belfast

Exhibition Catalogues

1973

Photography Into Art, Camden Arts Centre,
London, 1973, artist's entry under
pseudonym 'Ace Posible'

1975

Artists Bookworks, The British Council, London,
1975

From Britain '75, Taidehall, Helsinki, 1975

1976

American Artists in Britain, The University
Gallery, Leeds, 1976

Kunstlerinnen International 1877–1977, NGBK,
Berlin

1978

Susan Hiller: Recent Works, Museum of Modern
Art, Oxford and Kettle's Yard, Cambridge,
1978, introduction by David Elliot, essay by
Caryn Faure Walker, text by the artist

Hayward Annual '78, The Arts Council of Great
Britain, London, 1978, text by Sarah Kent

1980

*About Time: Video, Performance and Installation by
21 Women Artists*, ICA, London, 1980, texts
by Lynn MacRitchie and the artist

1981

*A Mansion of Many Chambers: Beauty and Other
Works*, Arts Council of Great Britain, London,
1981, text by David Brown and the artist

Books by Artists, Art Metropole, Canada, 1981,
texts by Germano Celant and Tim Guest

New Works of Contemporary Art and Music, The
Fruitmarket Gallery, Edinburgh, 1981

1982

*Artists' Books: From the Traditional to the Avant
Garde*, Rutgers, The State University of New
Jersey, 1982

Sense and Sensibility in Feminist Art Practice,
Midland Group Gallery, Nottingham, 1982,
text by Lisa Tickner

Visions of Disbelief, 4th Biennal of Sydney, 1982

1983

Photo(graphic) Vision, Winchester Gallery, 1983,
text by Sue Arrowsmith

1984

The Selectors' Show, Camerawork, London, 1984,
text by Maureen Paley

New Media 2, Malmö Konsthall, Sweden, text by
John Roberts (extract from Patrons of New
Art Newsletter), 1884

Sensations of Reading, Regional Art Gallery,
London, 1984, text by Tim Guest

Susan Hiller 1974-1984: The Muse My Sister,
Derry, 1984, interview with the artist by
Rozsika Parker, texts by Guy Brett and John
Roberts

The British Art Show, The Arts Council of Great
Britain, London, 1984, text by John
Thompson

1985

Hand Signals, Ikon Gallery, Birmingham, 1985,
text by Guy Brett

The British Show, The Arts Council of Great
Britain, London, 1985, text by Lynne Cooke

Identities, Centre National de la
Photographie/Edition du Chene, Paris, 1985

Kunst Mit Eigen-Sinn, Museum Moderner Kunst,
Vienna, 1985, text by John Roberts

Livres d'Artistes: Collection Semaphore, Centre
Georges Pompidou, Paris, 1985

The Irish Exhibition of Living Art, The Arts Council
of Great Britain, London and Dublin
Corporation, 1985

*British Film and Video 1980-1985: The New
Pluralism*, Tate Gallery, London, 1985, text by
Tina Kean and Michael O'Pray

Human Interest: Fifty Years of Art About People,
Cornerhouse Gallery, Manchester, 1985, text
by Norbert Lynton

1986

*Staging the Self: Self-Portrait Photography 1840s-
1980s*, National Portrait Gallery, London,
1986, texts by Susan Butler and James
Lingwood

Contrariwise: Surrealism and Britain 1930-1986,
Glynn Vivian Art Gallery/ Swansea Museum
Service, 1986, texts by Rozsika Parker and
Ian Walker

Between Identity and Politics: A New Art, Gimpel
Fils, London and New York, 1986

Susan Hiller: Out of Bounds, ICA, 1986, text by
Lucy Lippard and the artist

Conceptual Clothing, Ikon Gallery, Birmingham,
text by Lucy Lippard 1986

1987

*Current Affairs: British Painting and Sculpture in the
1980s*, Museum of Modern Art, Oxford,
1987

*Photomation: A Contemporary Survey of Photobooth
Art*, Pyramids Art Center, New York, 1987,
pp.8, 30, illus.

State of the Art, ICA, London, text by Sandy
Nairne, 1987

1988

One Hundred Years of Art in Britain, Leeds City Art
Gallery, 1988, foreword by Frances Spalding

British Art: The Literate Link, Ashure/Faure
Gallery, Los Angeles, 1988, text by Lynne
Cooke

1989

Americans Abroad, Artangel, London, 1989

Lifelines/Lebenslinien, Tate Gallery Liverpool and BASF, Germany, 1989, introduction by Lewis Biggs, text by Jean Fisher

Susan Hiller, Galerie Pierre Birtschansky, Paris, 1989, text by Jill Lloyd

Through the looking Glass: Photographic Art in Britain 1945-1989, Barbican Art Centre, London, 1989

Picturing People: British Figurative Art Since 1945, The British Council, London, 1989, text by Norbert Lynton

The Nude, a New Perspective, V & A, London, 1989, text by Gill Saunders

Towards a Bigger Picture II, V & A, London (Aperture) texts by Mark Haworth-Booth and Susan Butler

1990

Signs of the Times: A Decade of Video Film, and Slide Tape Installation in Britain, 1980-1990, The Museum of Modern Art, Oxford, 1990, pp.20-24, 41-42, 65-66

Susan Hiller: The Revenants of Time, Matt's Gallery, London; Mappin Gallery, Sheffield; Third Eye Centre, Glasgow, 1990, text by Jean Fisher

Great British Art, Glasgow Museum and Art Gallery, text by Julian Spalding, 1990

1991

Present Continuous, Bath Festival, 1991

Shocks to the System: Social and Political Issues in Recent British Art, The Arts Council of Great Britain, London, 1991, pp.48-49

The New Urban Landscape, World Financial Center, New York, 1991

Exploring the Unknown Self: Self Portraits of Contemporary Women, Metropolitan Museum of Photography, Tokyo, 1991

1992

Dark Décor, Independent Curators Inc., New York, 1992, text by J. Cirincione and T. Potter, illus.

In Vitro de Les Mitologie del Ferilitat als Limits de Ciencia, Departmenta de Cultura de Generalitat de Catalunya, Spain, text by Anna Velga and Vincenç Velga, Catalan and English, 1992

1993

Les Signes des Temps, The British Council/La Ferme du Buisson, Paris, 1993, text by Anne-Marie Dugnet

1994

Susan Hiller's Brain, Gimpel Fils, London, 1994, text by Michael Corris

Worlds in a Box, London, 1994, The Arts Council of Great Britain, text by Alexandra Noble

Punishment and Decoration, Hohenthal & Burgin Gallery, Cologne, 1994, text by Michael Corris

1995

Rites of Passage: Art for the End of this Century, Tate Gallery, London. Text by Stuart Morgan and Frances Morris

1996

Inside the Visible: An Elliptical Traverse of 20th century Art, ICA, Boston, 1996, text by Jean Fisher

Photographic Credits
Arts Council of Great Britain pp.48, 81
Book Works pp.85, 86, 88, 89
Gimpel Fils Gallery pp.60, 68
Matt's Gallery pp.40 (lower), 83
Dave Lambert and Mark Heathcote pp.31-33
Adam Ritchie p.61
Roger Sinek pp.6, 8, 12, 13, 18, 19, 29, 36, 37, 46, 47, 82
Chris Swayne p.63 (centre)
Steve White p.85, 86, 88, 89
Edward Woodman p.21, 40, 41, 65, 67, 68, 70, 71, 75, 83

This book is published to accompany an exhibition organised by
Tate Gallery Liverpool

Susan Hiller
20 January until 17 March 1996

Prepared by Tate Gallery Liverpool

Published and distributed by Tate Gallery Publishing,
Millbank London SW1P 4RG

Designed by Herman Lelie
Typeset by Goodfellow & Egan, Cambridge
Printed by BAS, Hampshire

Copyright © Tate Gallery and the authors

ISBN 1-85437-189-4

Front cover: Susan Hiller, Automatic writing
Back cover: Susan Hiller, 39. *Bright Shadow* (1994)